Debra N. Mancoff

Fashion in Impressionist Paris

MERRELL
LONDON · NEW YORK

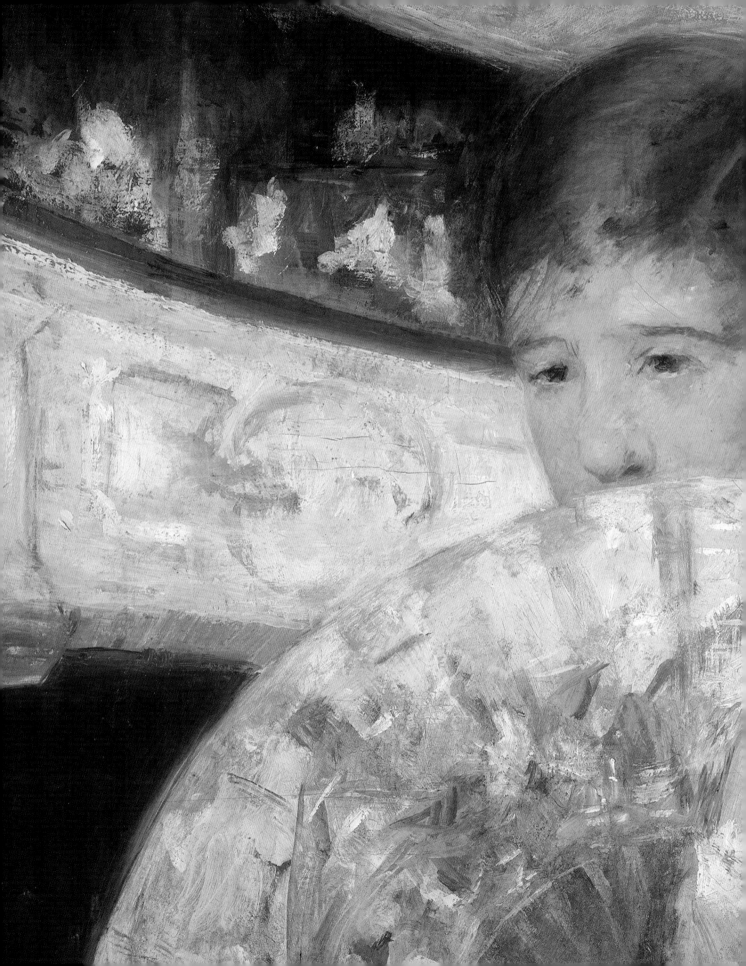

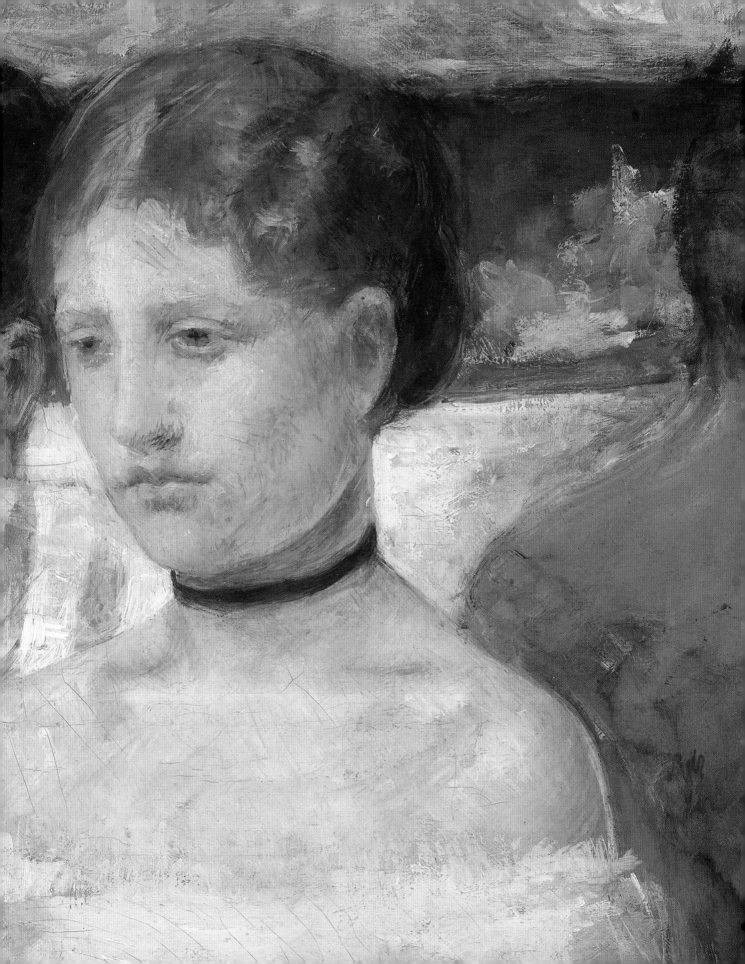

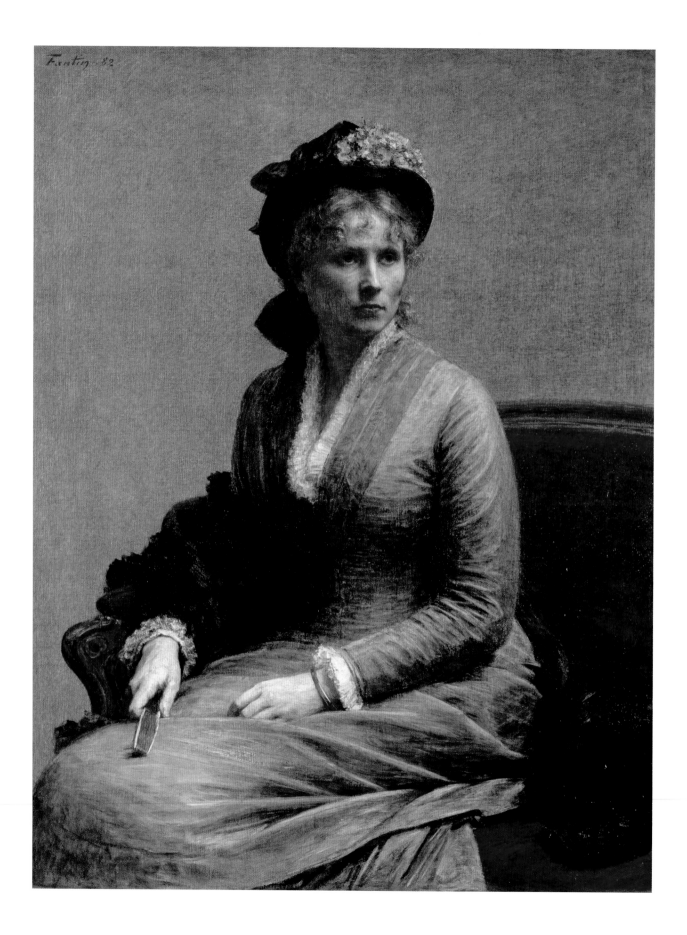

The Style of Modernity

In his groundbreaking essay 'The Painter of Modern Life' (1863), the provocative poet Charles Baudelaire issued a bold challenge to the artists of his generation, urging painters to leave their studios, mingle with the crowds on the streets and draw inspiration from the authentic characteristics of contemporary life. The old canon of subject matters, based on myths and legends, history and the Bible, no longer had relevance in the modern world. Life had changed, and the true artist looked to the present, rather than the past, in pursuit of the singular quality that gave a moment its distinction, a quality that Baudelaire called 'modernity'.

The very nature of modernity was elusive, for, as Baudelaire explained, the essence of a moment could be discovered only in 'the ephemeral, the fugitive, the contingent'. Fleeting details of mundane activity – the simplest 'gait, glance and gesture' – distinguished each age from all others, and an artist in touch with his times would recognize the poetry in the little habits and details of daily life. Throughout history, the poet argued, every 'old master has had his own modernity', but each had been able to create work that remained vital through the ages. That mastery came through what he believed was the essential power of great art: 'to distil the eternal from the transitory'.[1] From his first published art reviews, Baudelaire had urged artists to make their art modern, but now more than ever the time was right for artists to take up the challenge, for at that very moment Paris was undergoing a remarkable transformation.[2]

In the previous decade Louis-Napoléon Bonaparte, the nephew of the late emperor, had seized power and, as Napoleon III, established the Second Empire (1852–70). With the support of the *haute bourgeoisie* – the most affluent sector of the middle class – he launched the defining project of his reign: a vast urban regeneration plan that would transform Paris into the most modern city in the

world. Tangles of narrow streets were cleared to make way for broad, straight avenues and spacious plazas. Derelict structures were demolished and replaced with handsome multi-storey buildings housing grand apartments above street-level shops and businesses. Life in Paris was made safer, more pleasant and healthier than ever before, thanks to new public facilities and amenities, including train stations, municipal parks, street lighting, public transport, and improved water and sewage systems. The programme, conceived and directed by Georges-Eugène Haussmann, prefect of the Seine region, of which Paris was the centre, was popularly known as 'Haussmannization'. The plan transformed the heart of the city, and, after the fall of the Second Empire in 1870, work continued through the early decades of the Third Republic (1870–1940).[3]

In *La Curée* (1872; *The Kill*), Émile Zola's novel set against the backdrop of Haussmannization, a shrewd speculator makes his fortune by manipulating the price of land parcels scheduled for demolition; as he describes his vision for the new city, with its broad avenues cutting through the old structures like a 'sabre', he predicts that 'whole neighbourhoods will be melted down, and gold will stick to the fingers of those who heat and stir the mortar.'[4] And he was correct. Investors, bankers and speculators grew rich through Haussmannization, and while it was true that the greatest beneficiaries of urban regeneration were the wealthy citizens who supported the regime, the whole of the middle classes, from the petit-bourgeois artisan to the *haute-bourgeoisie* elite, saw their lives change. The newly revitalized city gave rise to a new culture. Life became more public. The commodious streets, with their appealing shops and cafés, were perfect for leisurely strolls. The parks offered diversions ranging from concerts to sports, as well as providing open grounds for picnics, paths for promenades, and well-placed benches on which to sit and watch the world pass by. And as Parisians had

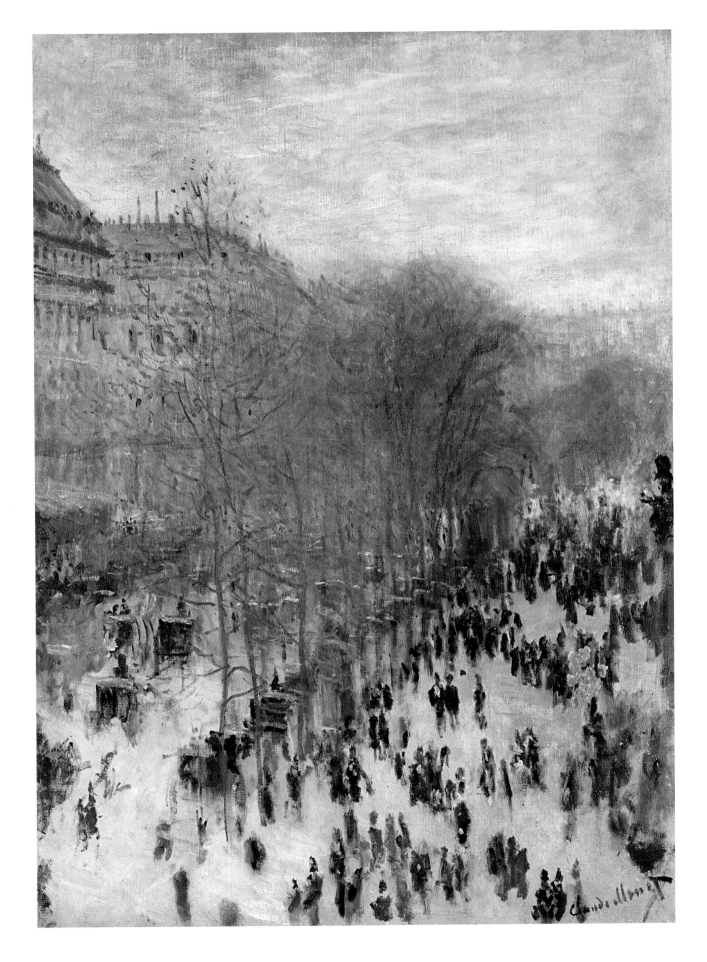

more money to spend, they dressed the part, making fashion the most prominent symbol of modernity.

The stage was set for the painter of modern life, and, whether prompted by Baudelaire's challenge or on their own initiative, a group of artists found their subject matters in their surroundings. Zola, writing for the journal *L'Évènement* in 1868, hailed 'those painters who love the times they live in', whose 'works are alive, because they have taken them from life'.[5] He called them 'les Actualistes,' in reference to the topicality of both their subject matter and their interpretation; their work captured the moment in real terms, as they knew it, felt it and lived it. In fact these artists, who included Édouard Manet (1832–1883), Edgar Degas (1834–1917), Claude Monet (1840–1926) and Auguste Renoir (1841–1919), did not seek to forge an organized movement with a united agenda. Rather, they comprised a circle of like-minded colleagues whose individual experiences of the conventions of the established art world convinced them that they needed to strike out in new directions. Some, such as Monet and Renoir, believed that painting should be done on location to capture the immediate sensation of natural light. Others, such as Manet and Degas, strolled the city, gathering ideas and sketching details to incorporate into their work in the studio. They painted in different styles and had different aesthetic perspectives, but they shared a common conviction to pursue their art in the spirit of modernity. In 1874 they launched an independent exhibition of their works, the first of eight such exhibitions over the span of twelve years. And although they did not name their group, they came to be known as the Impressionists.[6]

The newly renovated streets teemed with action, and a lively perspective on modern life could be discovered outside a window or beneath a balcony. To view the bustling Opéra district, Monet climbed to the top storey of a building on the boulevard

Gustave Caillebotte (1848–1894)

A Balcony in Paris

1880

Oil on canvas

66 × 60 cm (26 × 23⅝ in.)

Private collection

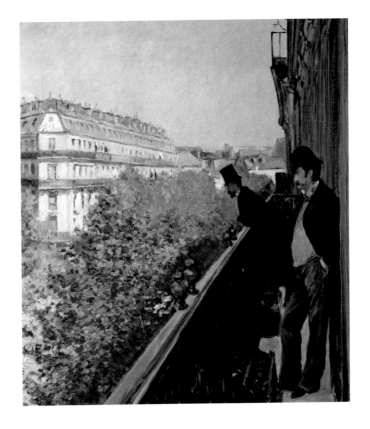

des Capucines. His friend the photographer Nadar (Félix Tournachon; 1820–1910) had a studio there, and, with his easel positioned near the window, Monet painted the panorama below (page 9). The wide street, divided by a stand of trees and flanked by buildings even taller than the one in which Monet stood, was alive with activity, and he used a deft, flickering brushstroke to convey the movement of the carriages, of pedestrians, and of the wind rustling through the branches of the trees. When Monet exhibited *Boulevard des Capucines* at the First Impressionist Exhibition – held in 1874 in the very space in which the work was painted – critic Ernest Chesneau was astonished at the artist's ability to translate 'this stream of life' in all 'its tremendous fluidity' into a fixed image on canvas.[7]

Gustave Caillebotte (1848–1894) painted *A Balcony in Paris* (above) from his own apartment on the boulevard Haussmann, and, rather than portraying the street scene itself, he presented two men leisurely enjoying the view. In 'The Painter of Modern Life' Baudelaire described a distinctly modern type of man: what he called the *flâneur* (gentleman stroller or loafer), the 'prince' of the city, a man whose wanderings took him to every district and whose sharp eyes observed every detail. The *flâneur* drew his energy from the 'ebb and flow' of the crowded city, but, although he immersed himself in the throng, he remained aloof, distinct and anonymous. Rather than being a participant, Baudelaire's *flâneur* was a 'passionate spectator' who never tired of the ongoing pageant of modern life.[8]

Caillebotte's spectators embody that spirit. They are comfortable on their perch – one leaning against the wall and the other over the balustrade – and confident that they themselves are unobserved. Their garments, along with their gestures, signal their identity. Both men are conventionally and well dressed. The man in the foreground wears a sack jacket, with a light waistcoat and contrasting

Gustave Caillebotte
(1848–1894)
The Pont de l'Europe
1876
Oil on canvas
124.7 × 180.6 cm (49⅛ × 71⅛ in.)
Musée du Petit Palais, Geneva

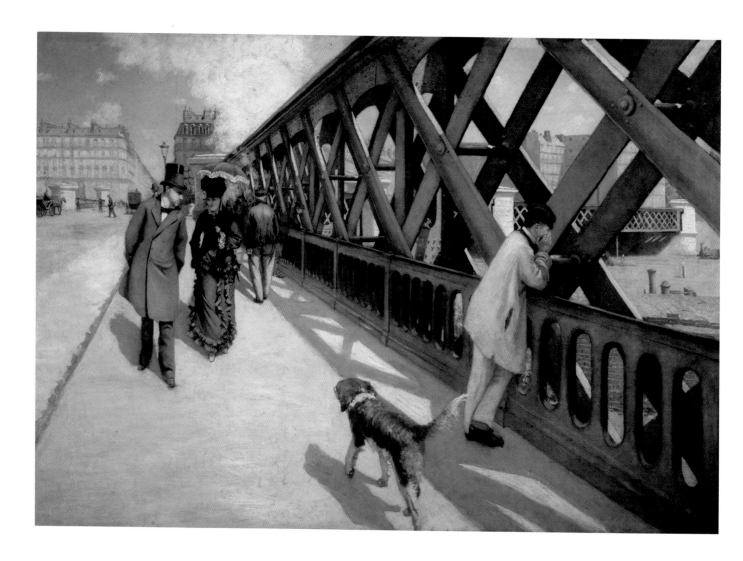

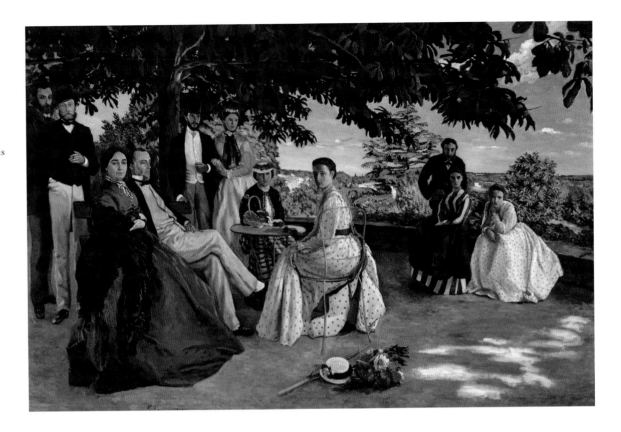

Frédéric Bazille
(1841–1870)
Family Reunion
1867
Oil on canvas
152 × 230 cm
(59⅞ × 90½ in.)
Musée d'Orsay, Paris

trousers; this combination, along with his homburg, constituted informal daywear. His companion wears a frock coat and a top hat, the elements of formal daytime attire. Their garments would have conveyed a comfortable level of affluence as well as conformance to social rank and decorum. The men were elegant and at ease with their identity; their appearance would warrant acceptance but not undue notice. Through their sartorial *savoir faire* they maintained the necessary state of 'incognito' required by the skilful *flâneur*.

Painting the scene from a window or a balcony offered an overview of life in the city; painting from the perspective of the street plunged the viewer right into the action. Many features in the new Paris plan provided ideal points for surveying the crowd: a park bench, a comfortable table at a pavement café, or even the street itself. But few matched the spectacular view from the Pont de l'Europe, an impressive iron bridge connecting six important avenues and spanning the train yard of the Gare Saint-Lazare.

A man could peer through the braces and watch the trains arrive and depart. But there was a more varied spectacle on the broad pavement, as men and women crossed the bridge, ambling for pleasure or purposefully heading towards a specific destination. In *The Pont de l'Europe* (opposite), Caillebotte offers the viewer a *flâneur*'s perspective.[9] The deep, oblique axis of the pavement punctures the centre of the painting and makes it seem as if the stylish pair of strollers are moving towards the viewer, soon to pass by as they traverse the bridge. Their elegant attire signals their social status: he wears the dark coat and top hat of formal daywear, and she is dressed in a fashionable promenade ensemble, enhanced by a rakish hat and a grey parasol. The lines of their clothing are impeccable, but the dark palette of fabrics – shades of black and grey – mark them as tasteful as well as stylish members of the upper middle class. In contrast, the jackets worn by the other men on the bridge position them further down the social ladder

James Tissot (1836–1902)
The Convalescent
1872
Oil on panel
37.5 × 45.7 cm (14¾ × 18 in.)
Art Gallery of Ontario, Toronto

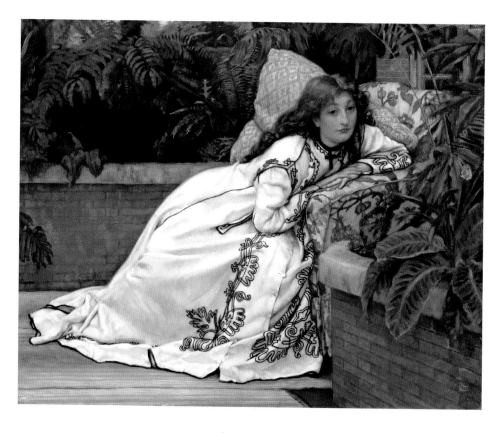

but still part of the middle classes. Both are in the building trades: the man in white is a painter or a plasterer, and the man in blue is a general hand on a construction site.

As is shown in the varied garments of the pedestrians on the bridge, clothing provided an articulate and accessible code of modern identity. Through their attire, men and women negotiated the complex worlds of public image, proper decorum and personal relationships. The practised *flâneur* was fluent in style, and Parisians dressed to be seen. But fashion, and particularly women's fashion, was constantly changing, and Baudelaire cautioned artists to notice every detail. The true painter of modern life had an 'eagle eye' that took note of every subtle change: the positioning of a chignon on the nape of a woman's neck, the fullness of her skirt, or a change in the choice of ornament.[10] In a culture that valued appearance, fashion mattered, and its innate characteristic

of constant and subtle change gave material form to the mutability of modernity.

Even within a circle of family and friends, details of dress made a difference. The keen attention given by Frédéric Bazille (1841–1870) to attire in *Family Reunion* (page 13) does more than fix the image of the family in a moment in time; it also reveals relationships and positions within the group. The hostess – and family matriarch – wears dark blue; her daughters wear white with blue sashes. Their guests, both male and female, retain their hats. The host's garments are similar to those of his guests, and the uniformity of the men's garments (they show only subtle differences in the cut of the jackets and the colour of the trousers) would carry them through the course of the day. But a woman's day required a variety of ensembles that conformed to the demands of her activities. For example, the daughters' white dresses are perfect for receiving guests, but far too informal to wear outside the home. The female

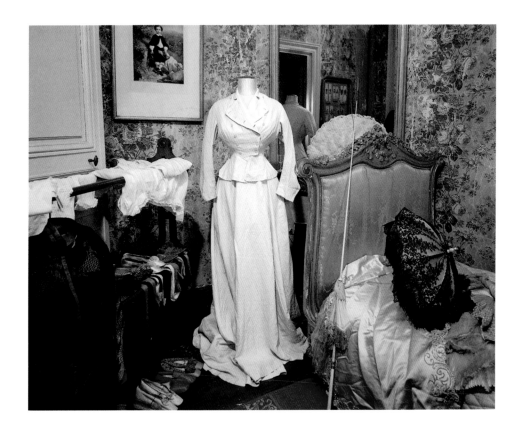

visitors – identifiable by their hats – wear darker colours, heavier textiles and more structured gowns. Loose garments, as featured in *The Convalescent* (opposite) by James Tissot (1836–1902), would be worn only in privacy, prior to lunch, or if a woman was indisposed. Each element of a woman's ensemble, from the trim on her hat to the lace on her cuff, contributed to her public image. Charlotte Dubourg, as portrayed by her brother-in-law Henri Fantin-Latour (1836–1904; page 6), presents a perfect balance of style and decorum. The silhouette of her day dress is fashionable, but her choice of fabric and colour is modest. Such details would not have gone unnoticed, and in a portrait they would have represented the attributes of a respectable woman.

Few women could afford as extensive a wardrobe as the fashionable wife of Napoleon III, the Spanish-born Empress Eugénie (above).[11] But the rules of dressing appropriately meant that, in order to maintain her image, a woman was expected to keep up with changing styles. Depending on her financial situation, she could freshen up old gowns with new trims, hire a skilled dressmaker (see pages 36–37), or purchase her wardrobe, as the Empress did, from one of the city's new and exclusive couturiers (see pages 56–57). A man on the rise regarded his wife's wardrobe as an investment in his own image; Zola's speculator, for example, liked to see his wife 'attracting the attention of Tout Paris', for it 'consolidated his position'.[12] In the new Paris, fashion became a lucrative industry, and, more than any other commercial concern, the *grand magasin* (department store) reflected the modern spirit of the city (see page 16; see also pages 78–79). The *grand magasin* represented upward mobility, as seen in Zola's *Au Bonheur des Dames* (1883; *The Ladies' Delight* or *The Ladies' Paradise*), a modern romance that follows the rise of a poor provincial girl, working in the womenswear department of a giant emporium, whose transformation into a sophisticated and independent

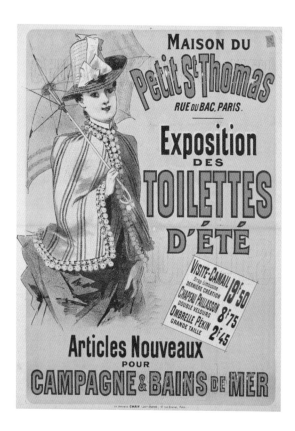

Jules Cheret (1836–1932)
Maison du Petit St Thomas
1886
Colour lithograph
124.5 × 88 cm (49 × 34⅝ in.)
Les Arts Décoratifs, Paris

woman wins the heart and hand of the dashing owner. Thanks to goods being offered at every price point, as well as to the emergence of a limited form of ready-to-wear clothing, more women were able to follow fashion; both men and women could now dress according to their aspirations rather than their actual circumstances.

As will be seen in the pages that follow, the artists of the era expressed the spirit of modernity through the language of fashion. The featured paintings, by Impressionist artists and their colleagues, follow the footsteps of the people of Paris as they stroll the parks and boulevards (see, for example, pages 46–47, 50–51 and 88–89), meet their friends at cafés (pages 102–103) and patisseries (opposite), take in the theatre (page 115), relax at home (pages 30, 64 and 70–71) or go on holiday (pages 122–27 and 132–35). Seen in the light of contemporary commentary, including that of art critics, journalists, fashion writers and novelists, these works bring to

life the fast-paced and fashionable decades of the 1860s through to the 1880s. *Fashion in Impressionist Paris* reveals that Baudelaire was right. By drawing inspiration from the lives they lived and the city in which they lived, these artists discovered the distinctive spirit of their times, and through their keen observations they transformed their fellow Parisians' fleeting 'gait, glance and gesture' – as well as the stylish appearance of their garments – into the iconic images of the epoch.

Jean Béraud (1849–1935)
La Pâtisserie Gloppe
1889
Oil on canvas
38 × 53 cm (14⅞ × 20⅞ in.)
Musée Carnavalet, Paris

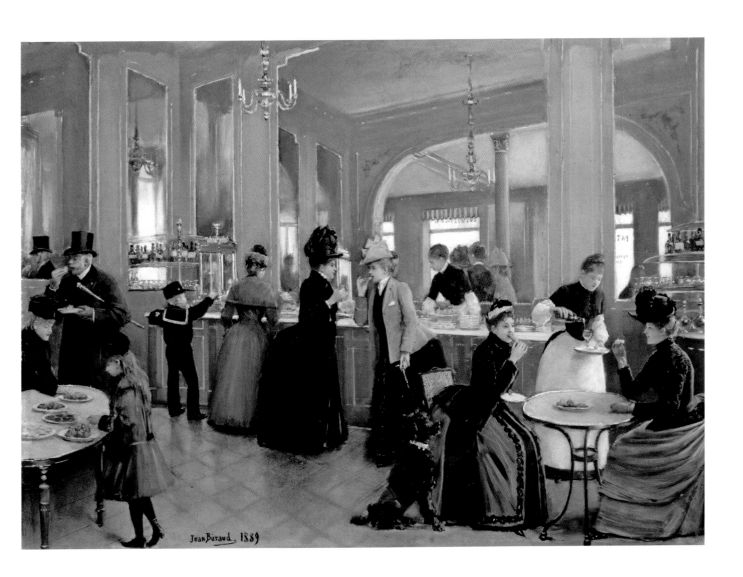

Cutting a Figure

When Georges Duroy, the handsome social climber in Guy de Maupassant's novel *Bel-Ami* (1885), accepts an invitation to dine at the home of a friend, he faces the problem of having nothing suitable to wear. After spending years as a non-commissioned officer posted in Algeria, and then months working as an office clerk, he has not been able to assemble a respectable wardrobe. His friend urges him to buy what he can and hire the rest, informing him that in Paris 'it's better to be without a bed than not to have evening clothes'.[1] Duroy follows his friend's advice, and, dressed in unfamiliar garments, nervously ascends the stairs to the apartment in which the dinner is to take place. But a glimpse in a mirror reveals that the clothing has transformed him: in evening dress he has the look of a 'man about town', 'extremely smart and distinguished'.[2] Now filled with confidence, Duroy makes his entrance, and by the end of the evening new opportunities have opened before him.

In Duroy's Paris, appearance was everything. Middle-class men and women, especially those on the rise, followed a strict dress code. They expressed their knowledge of society through the garments they wore; clothing was a tangible performance of etiquette. A socially skilled man or woman knew what to wear, selecting costumes in accordance with time of day, nature of event and calibre of company. But clothing was also seen as a sign of character. Cutting an elegant figure was a delicate matter of balancing taste with flair, fashion with tradition, and individuality with conformity.

Both during the day and in the evening, men wore a sort of uniform: coat, waistcoat and trousers. The smallest details made a difference. Exquisite tailoring indicated self-respect as well as wealth; such fine accessories as supple gloves, a silver-tipped cane and a well-brushed hat added dash, but only if chosen with restraint (see page 23). A tasteful man never strayed from the nearly monochromatic

Fashion photograph
c. 1860
Collection Bernard Garrett

palette of black and grey, whether dressing for dinner or business, or even for a stroll in the park (see page 27). Women could choose from a rainbow of colours, a wardrobe of styles and an array of ornaments, but their dress code was far more complex and constantly subject to the whims of fashion. Women also had to embody both beauty and respectability, whether at home (see page 31) or in the ballroom (see pages 32–33), for, as the journalist and fashion writer Octave Uzanne reminded his readers, dress was 'the first of the arts', but it was also a woman's 'armour'.[3]

Claude Monet
(1840–1926)

Woman in a Green Dress

In his review of the Académie des Beaux-Arts' Salon of 1866, the writer Émile Zola praised Claude Monet's depiction of a young woman in a vibrantly striped skirt and fur-trimmed *paletot* jacket as a 'window opened on nature'. The painting, which is nearly life-size, captivated Zola with its vitality and energy. Although he claimed to know neither the artist nor the sitter, he felt a deep connection to the work. It portrayed a real woman, dressed in 'good solid silk'.[4] Monet's companion, Camille Doncieux, who would later become his wife, modelled for the work, and it was a good likeness, but this was not a portrait in any conventional sense. In the turn of her head, the tilt of her hat and the sweep of her skirt, Doncieux personified a new feminine ideal. An anonymous critic, writing for the journal *L'Artiste*, dubbed the painting the 'Queen of Paris'.[5]

The domain of this new 'Queen' was the modern city, with its fashionable shops, wide avenues and lively cafés, and Monet depicted his model in the season's latest street ensemble: the small hat, the swing-cut *paletot* and a skirt more voluminous in the back than in the front.[6] The sheen of silk and the plush textures of fur and velvet project luxury, but the ensemble could also have been purchased ready-made in less expensive fabrics: following fashion trends was no longer the exclusive privilege of affluence. Similarly, the ambitious scale of Monet's canvas emulates contemporary society portraiture, but his model's pose mirrors that of a mannequin in a fashion plate or a dressmaker's photograph.

1866
Oil on canvas
231 × 151 cm
(90⅞ × 59½ in.)
Kunsthalle Bremen

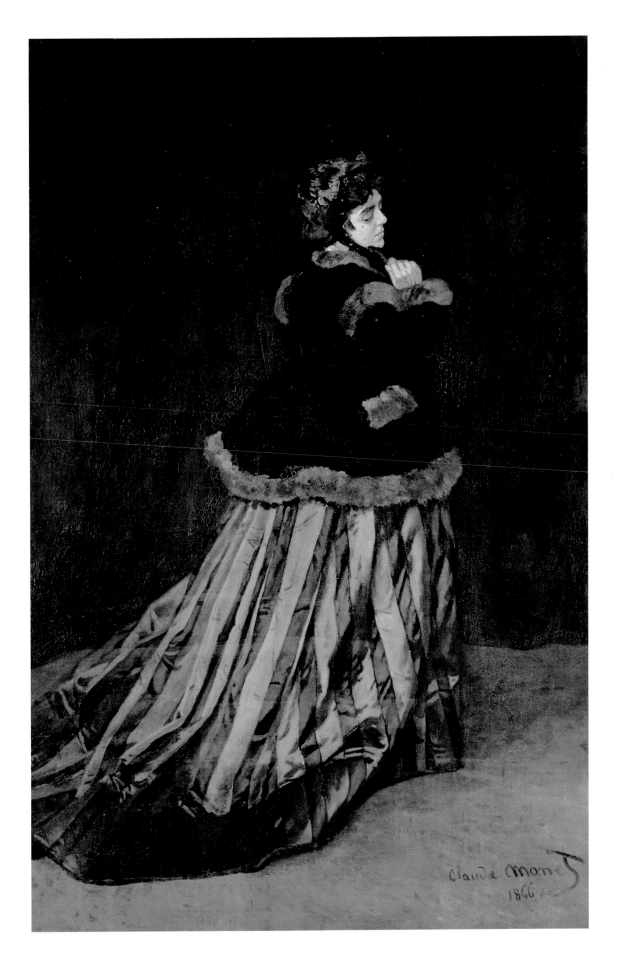

Claude Monet
1866.

Henri Fantin-Latour

(1836–1904)

Édouard Manet

1867
Oil on canvas
117.5 × 90 cm
(46¼ × 35½ in.)
The Art Institute
of Chicago

From the sheen of his silk top hat to the glint of the silver tip on his cane, Édouard Manet cuts an elegant figure. He wears a sack coat – the prototype of the present-day suit jacket – over a plain, high-buttoned waistcoat. His smoothly fitted, light-grey trousers contrast strongly with the deep black of his roomy jacket. His tie, bright against a white shirt, adds a subtle dash of colour to an otherwise severe ensemble. Manet is dressed to stroll along the streets of Paris; in common with the *flâneur* (gentleman stroller) conceived by the poet Charles Baudelaire, he blends in with the crowd in order to draw energy and inspiration from the city's vitality.

Manet's conservative but well-made garments indicate his social status as securely bourgeois; his father was a successful magistrate and judge. A poem by Théodore de Banville describes the painter as 'emanating grace' and having 'from head to toe/ The appearance of a gentleman'.[7] Henri Fantin-Latour's portrait, inscribed *A mon Ami Manet* ('For my Friend Manet'), indicates neither Manet's profession nor his reputation as an iconoclastic painter of modern life. A critic who saw the painting at the Salon of 1867 expressed surprise that Manet looked so conventional; he had assumed that the artist was a long-haired bohemian.[8]

For this portrait, Manet himself chose his pose and his garments. Every detail, from the slight tilt of his hat and his neatly groomed ginger beard to his gold watch chain and fine leather gloves, reflected Manet's typical manner of dress. Although he was fearless in defying prevailing dictates in art, when he dressed he embodied decorum.

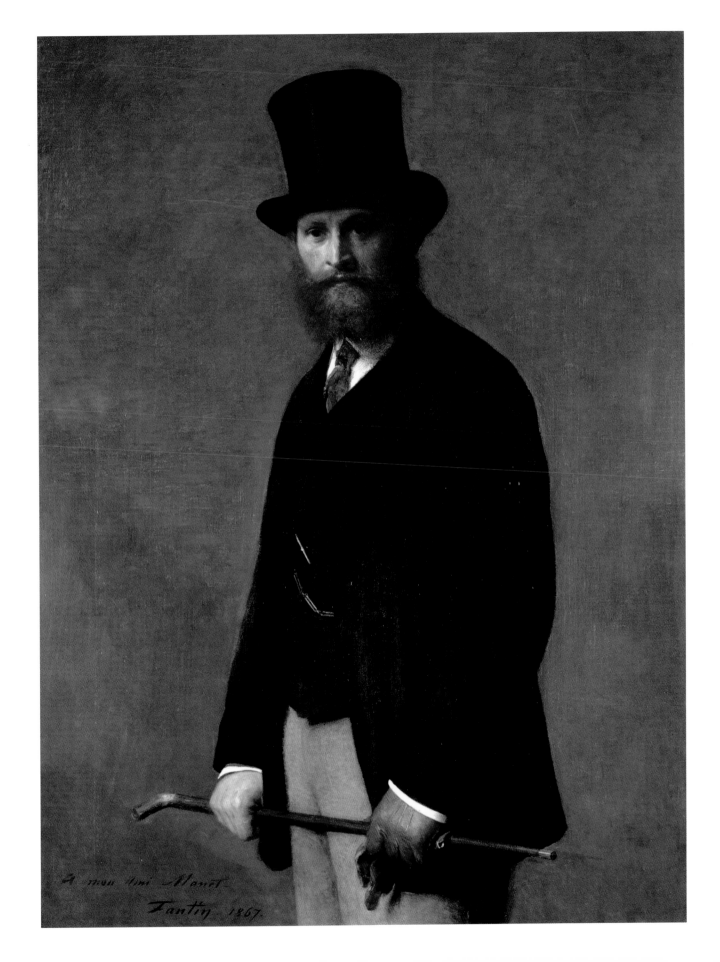

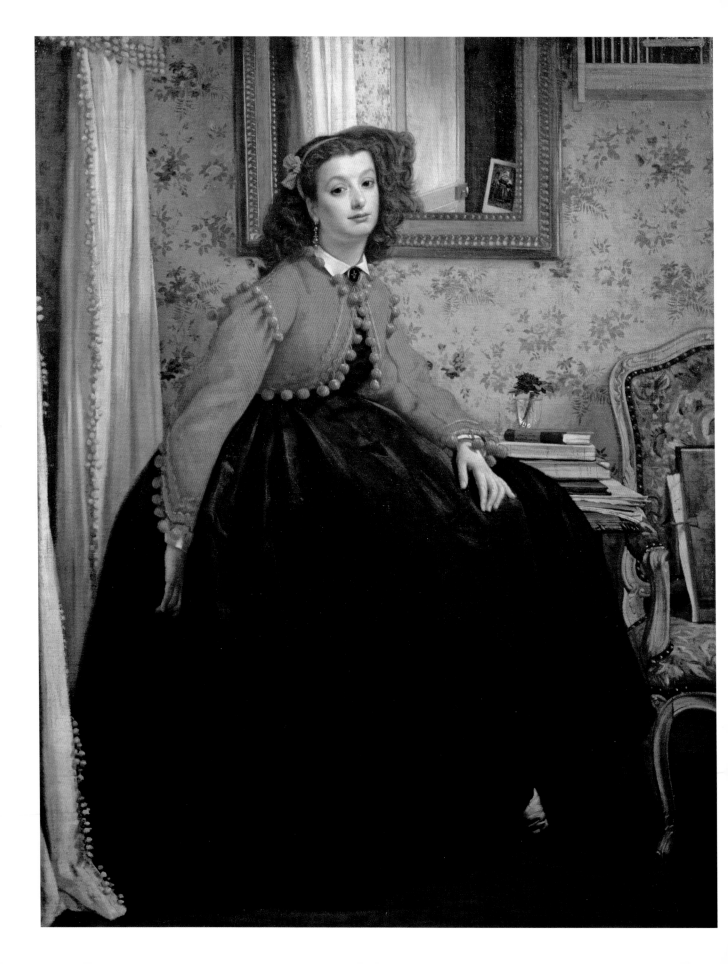

James Tissot

(1836–1902)

Portrait of Miss L.L.

1864

Oil on canvas

124 × 99.5 cm

(48⅞ × 39¼ in.)

Musée d'Orsay, Paris

The voluminous skirt defined the feminine silhouette for much of the Second Empire (1852–70). Cage crinolines, patented in 1856, eliminated the need for multiple layers of petticoats, but once the largest circumference was reached in 1858, the essential shape of the skirt was continually redesigned.[9] From the early 1860s, the development of graduated hoops allowed an even transition from the narrow span of the waist to the broad diameter of the hem, and, at the top of the skirt, pleats replaced gathers for a smooth fit under the waistband. James Tissot's sitter, Miss L.L. (she has not been identified) wears a voluminous, bell-shaped skirt, but by this time, the fashion for wide cage crinolines was beginning to wane. The soft folds of Miss L.L.'s skirt appear to be arranged across the table on which she perches, rather than supported on an understructure of hoops.

Miss L.L.'s striking red-and-black ensemble reveals another trend of the early Second Empire: dress *à l'espagnole*. At the time, elements of traditional Spanish dress were being glamorized by a number of factors, including collections of Spanish paintings and the performances of celebrated Spanish dancers, as well as the Empress's origins.[10] But these elements were deployed in a very untraditional manner, as seen in the sitter's snugly fitted bolero worn over a modest, high-necked corsage, itself trimmed with a prim white collar and crisp white cuffs. While the combination of colours and the bolero can be attributed to the Spanish vogue, the adoption of a foreign style of jacket that had originally been designed for men was part of a larger trend in women's daywear, and provided an eye-catching, exotic foil for the simpler, smoother skirt.[11]

Auguste Renoir
(1841–1919)

The Couple

c. 1868
Oil on canvas
105.4 × 75.2 cm
(41½ × 29⅝ in.)
Wallraf-Richartz-Museum,
Cologne

In the late 1860s, the elaborate trends in women's daywear presented a striking contrast to the simple, conservative garments worn by men. In Auguste Renoir's portrayal of a couple strolling in a park, the man wears a standard three-piece suit – black frock coat with a high-buttoned white waistcoat and grey trousers – and carries a top hat. The woman's gown is bright, mixing colours, fabrics and trim in an overall silhouette that recalls the eighteenth-century *polonaise*, a dress elaborated with a partial overskirt embellished with decorative puffs at the sides and back.

The dress featured here has a triple skirt. The hoops beneath the striped underskirt are flattened in the front in order to move the volume towards the back, in the latest fashionable silhouette. Over this is another underskirt, solid red and shaped into puffs by drawing up tapes hidden in the seams; a fringe finishes the scalloped hem, and the straps of the matching low-cut corsage are also scalloped. The third layer is a *tablier*, an apron-like overskirt made of diaphanous fabric cut in petals, edged with ruching and tied on at the waist. Under the corsage, the woman wears a long-sleeved *chemisette* in a similar fabric with narrow ruched trim.

The identity of the figures is uncertain.[12] But their affectionate behaviour, stopping along their way to share a fond gaze and a caress, defines their relationship. In fact, the double pose was a common one used at photography studios for engagement portraits (see pages 96–97). Note how the man graciously offers his arm to the woman. His left hand is gloved, but hers is bare and clearly displays a ring.

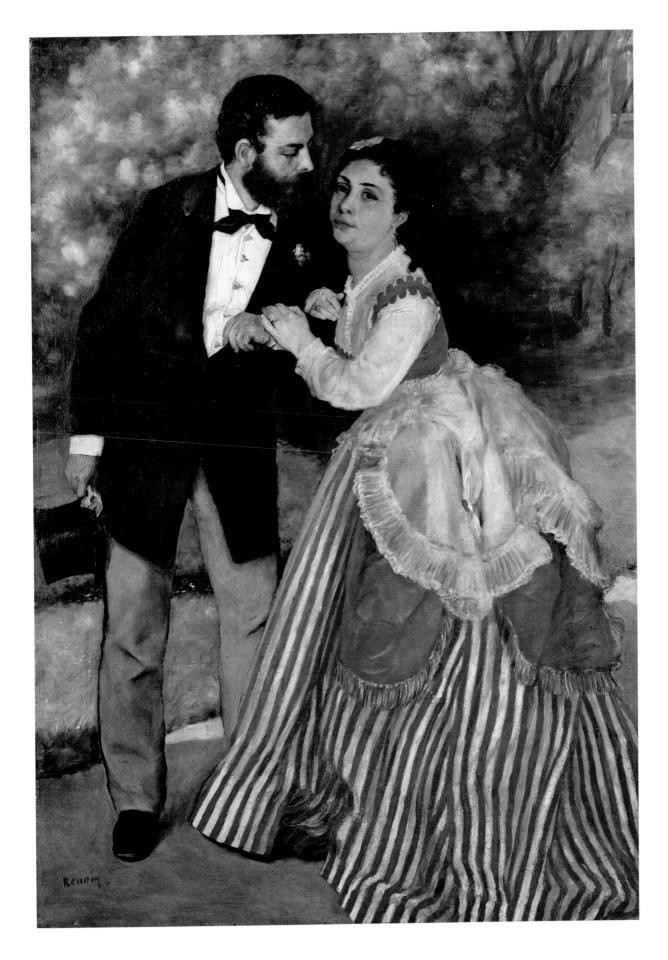

Carolus-Duran
(1837–1917)

The Lady with the Glove

When dressing for a daytime social visit or a walk in the fashionable districts of the city, a middle-class woman needed to strike a balance between attractive style and respectability. Too plain an appearance would convey a lack of interest in society; an out-of-date ensemble might suggest that her family had suffered an economic decline; yet displaying too much flair could be misinterpreted as superficiality, or as a bid for compromising attention.

The promenade costume depicted in Carolus-Duran's *The Lady with the Glove* is both fashionable and decorous, stylish enough to attract admiration but designed to communicate a sense of dignity and self-respecting reserve.

The soft silhouette was a new development; the previous year, the couturier Charles Frederick Worth (see pages 56–57) had convinced some of his more daring clients to give up their crinolines. Reduced volume at the front of the skirt shifted the emphasis to the back. The train of this gown – it would be looped up for walking – as well as the large bowed sash with long, lace-trimmed tails, would cut an elegant figure for a woman's promenade.

The corsage is simple, well-fitted and worn with a small lace wrap. More black lace, in the form of a fascinator, embellishes the feathered hat. Touches of colour relieve the severity of the all-black ensemble: an ivory-tinted rose on the hat, a red rosette on the wrap, and an exquisite pair of pearl-grey gloves. When the writer Henry James saw the painting, a portrait of the artist's wife, Pauline, he described it as 'admirably rich and simple'.[13] The perfect balance had been achieved.

1869
Oil on canvas
228 × 164 cm
(89¾ × 64½ in.)
Musée d'Orsay, Paris

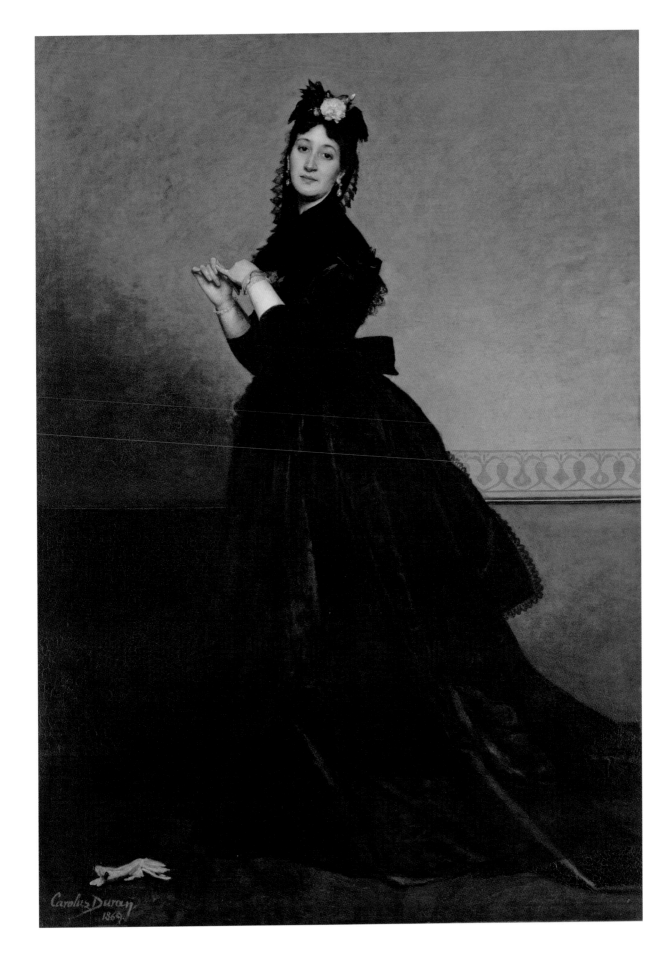

Édouard Manet
(1832–1883)

Repose

1870–71
Oil on canvas
150.2 × 114 cm
(59⅛ × 44⅞ in)
Museum of Art, Rhode
Island School of Design,
Providence

Between 1868 and 1874, the artist Berthe Morisot (1841–1895) repeatedly posed for her friend and fellow painter Édouard Manet.[14] In most of the images, Morisot appears in either a black or a white ensemble, selected to highlight her pale complexion, dark eyes and lustrous brown hair. The white ensembles were at-home gowns, as seen in the simple, high-waisted dress she wears in *Repose*. Both the gown and the setting imply an informal but private atmosphere: a woman, relaxing in her parlour in a comfortable day dress, ready to welcome the company of family or very close friends.[15]

The drape and flow of the supple fabric reveal that Morisot is wearing petticoats without a hooped structure to support them; by 1870 crinolines had gone out of style (see pages 140–41). Although she lounges on a well-upholstered settee, her slightly tilted upright posture indicates that she is wearing stays. Even when staying at home, a woman would not leave her boudoir until she was laced into her corset. The simplicity of the gown, with its modest ornaments of black velvet at the neck and waist, emphasize Morisot's own striking beauty; the dress seems as much an artistic element as a fashionable choice.

When Manet exhibited the work at the Salon of 1873, most critics objected to the informality of Morisot's posture and the starkness of the composition. According to prevailing thought, neither presented a woman to her best advantage. But after the exhibition Irish writer George Moore, a friend of Manet, saw the work in the painter's studio and understood it as a vision of modernity, declaring: 'The dress is the picture.'[16]

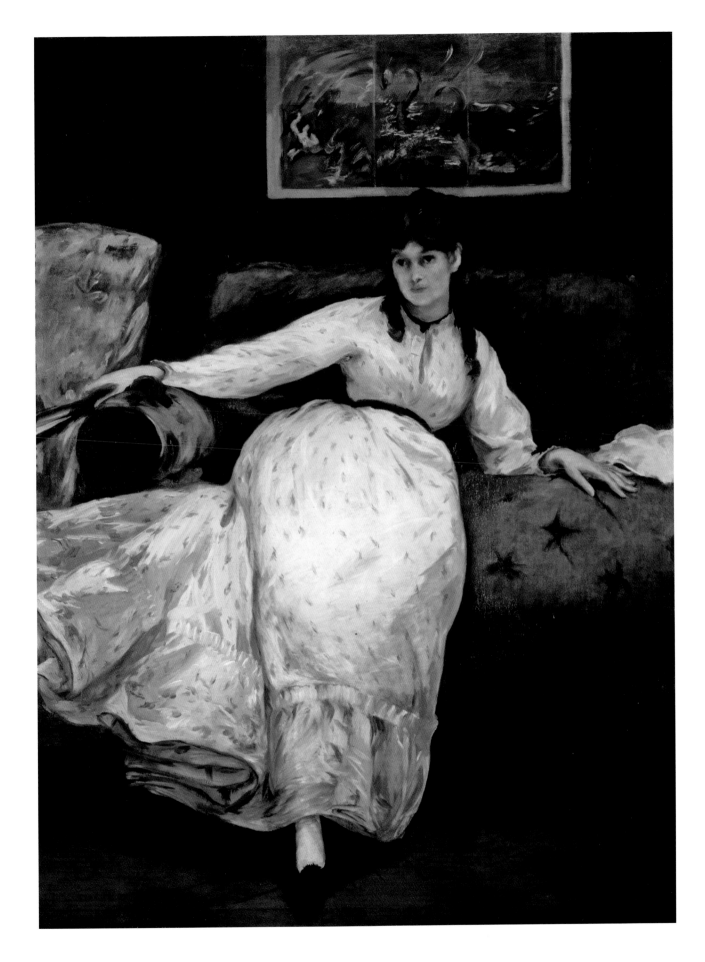

James Tissot
(1836–1902)
Too Early

As the son of a linen draper and a milliner, James Tissot had observed the elements of garment construction from an early age. By the time he was making his successful debut in the Salon in 1859, few painters could match his accurate rendering of clothing. He earned recognition for historical narratives, but by the 1860s his interest was shifting to social vignettes featuring genteel humour and fashionable women. After he relocated to London in 1871 his work retained a sophisticated French flair.[17] Tissot was well aware that, while London was the centre for men's tailoring, in women's fashion, Paris reigned supreme.

Too Early gently mocks the faux pas of punctuality. As the yellow-gowned hostess gives last-minute instructions to the orchestra and laughing housemaids peek into the ballroom, self-conscious first guests wait for other arrivals. The women's gowns are spectacular, displaying the elaborate ornamentation of the season, as seen in the draped *tablier*

(apron) fronts, side poufs, back puffs and tiered flounces of their skirts. Jay's of Regent Street, an elite supplier of silks and millinery, attributed the vogue for embellishment to the current French compulsion to make 'luxuries ultraluxurious'.[18]

The scooped, off-the-shoulder corsage, and the pale tones of the fabrics, distinguish ball gowns from dresses deemed appropriate for dinner parties or the opera, which had a higher-cut corsage. Short gloves and revealing décolletage demanded some concession to modesty: women covered their bare skin with opalescent powder. In their beribboned tulle confections, the women look their best, but, sadly, there is no one there yet to admire them.

1873
Oil on canvas
71.1 × 101.6 cm
(28 × 40 in.)
Guildhall Art Gallery,
London

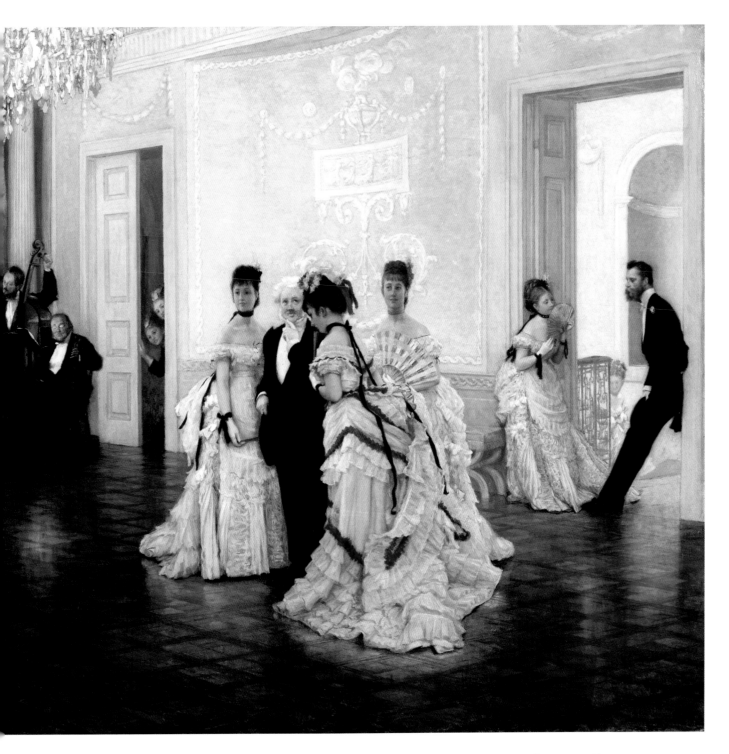

James Tissot
(1836–1902)

The Ball on Shipboard

When James Tissot first showed *The Ball on Shipboard* at the Royal Academy of Arts in London, boating enthusiasts immediately recognized the setting: the afternoon dance of the annual Royal London Yacht Club regatta, held on the deck of a man-of-war anchored off Cowes on the Isle of Wight. But the painting also appealed to exhibition visitors with a discerning eye for fashion; as well as providing an accurate view of the ship rigged up with flags for the regatta, Tissot offered a thorough overview of the latest afternoon styles from Paris. The featured daytime ensemble of the year was the promenade costume, which consisted of a tailored corsage and a slim skirt augmented with a *tablier* front, side puffs and an elaborate *tournure* (bustle).

Tissot represents several variations on this basic theme, and throughout the painting he portrays identical ensembles on different women as if they are posing for a fashion plate that illustrates the garment from different points of view. For example, the women in the centre right of the composition wear the same white dresses with navy-blue trim. The smart details of the snug corsage, with its inset panel in front, jaunty buttons and officer's collar, can be seen on the woman who faces the viewer. The woman in profile displays the elaborate layered skirt of the season, with its short, draped overskirt, side puffs anchored with navy-blue ribbons, and the looped and gathered *tournure* supported by a *crinolette*, or half-crinoline. The women complete their costumes with flirtatious straw boaters, tipped forward above their high chignons.

c. 1874
Oil on canvas
84.1 × 129.5 cm
(33⅛ × 51 in.)
Tate Gallery, London

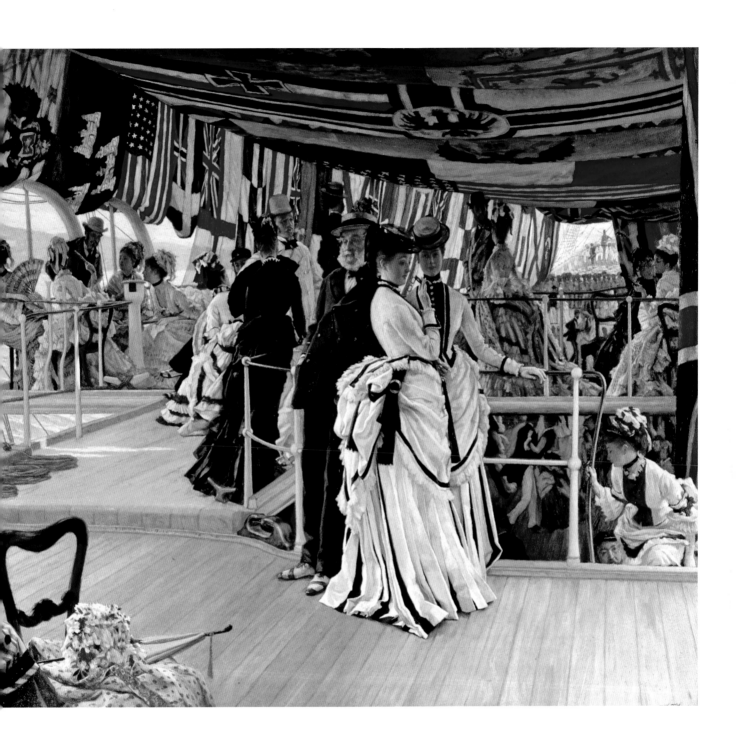

INTERLUDE
The Dressmaker and the Draper

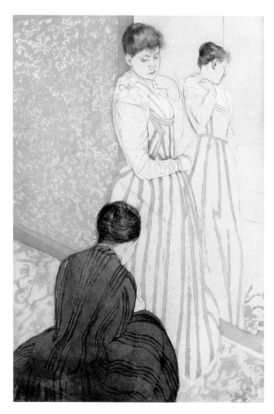

Mary Cassatt (1844–1926)
The Fitting, 1890–91
Drypoint and aquatint etching
43.8 × 30.5 cm (17¼ × 12 in.)
Brooklyn Museum, New York

A dressmaker and her client enjoyed a special relationship. A woman relied on her dressmaker to advise her on the latest fashions, to help her select a flattering style and the appropriate material, and to construct and custom-fit the gown to her satisfaction. The most successful dressmakers presided over large establishments with a handsome showroom, assistant seamstresses, and even a small selection of samples and fabrics. Less exclusive – and less expensive – services were available in more modest shops, or from independent seamstresses who did all the work themselves and worked from their own homes. No matter the circumstance, the dressmaker was always a woman, and her taste was considered to be as essential to her professional standing as her skills.

The creation of a new ensemble began with a series of consultations. The dressmaker showed her client a collection of fashion plates illustrating the silhouettes, style lines, colours and accessories of the season. Based on the type of garment desired, and the client's age, figure and budget, the dressmaker would guide her client to the right selection. She would then recommend fabrics, take measurements, and calculate the required metreage and such additional extras as lace, buttons and other trim. Dressmakers often had agreements with individual drapers; some acquired the material and trim as part of their service, while others directed clients to their colleagues' shops.

A draper's boutique featured only one type of cloth; silk, cottons and woollens were sold in different establishments. Some shops offered a limited selection of trims, but, in general, in order to acquire all the materials with which to make a gown, the customer had to visit several boutiques. When a customer entered a draper's shop, she was expected to make a purchase; there was no browsing. She would give the draper her dressmaker's instructions, and the draper would display his goods, one bolt at a time, unrolling the fabric and extolling its qualities until the customer made her selection.

Although draper's shops did hire female assistants, the main work was handled by men. A draper's wife was expected to be on the premises to put customers at their ease, but she dressed carefully so as not to outshine them. Auguste, the silk draper in Émile Zola's novel *Pot-Bouille* (1883), warns his frivolous wife, Berthe, that if she wants to sell silk, she must wear wool.

Heloise Leloir (1820–1874)
Fashion Plate: Afternoon Dress for Women, 1863
Watercolour on paper
Musée Carnavalet, Paris

Making even a simple dress required many fittings (always over the client's corset), as well as sewing skills beyond those of most ordinary women. But many dressmakers left the hems and other minor details to be finished by the client, as they demanded no special skills or sewing machine. And whichever dressmaker a woman used, new dresses were expensive. Women regularly freshened up their old dresses by altering the style lines, changing outdated details and replacing the original collars, cuffs, buttons and trims with new embellishments.

[Grey] French dress, 1860
Dress in two parts (silk corsage under blouse and skirt)
Les Arts Décoratifs, Paris

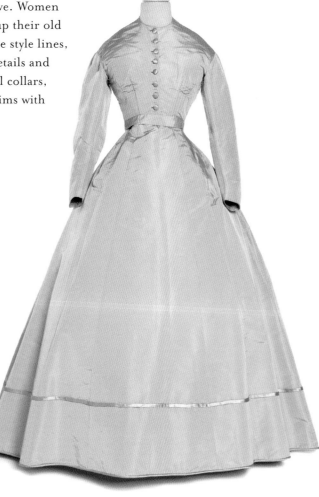

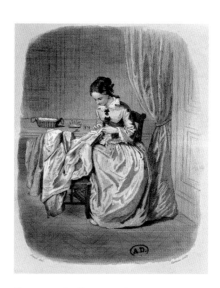

Engraving by Gervais, after
Pierre Gustave Eugène Staal (1817–1882)
A Couturier at Work, 1854, engraving
Bibliothèque des Arts Décoratifs, Paris

On the Street

In the early years of the Second Empire (1852–70), Napoleon III launched the project that would define his regime: the renovation of Paris. Over the next two decades, an unprecedented programme of urban regeneration, directed by the prefect of the Seine region, Georges-Eugène Haussmann, transformed every aspect of the centre of the city.

Old, crumbling buildings were demolished, clearing land for new commercial developments and multi-storey residences. A geometric plan, organized along a north/south axis, imposed strict order on what had been a jumble of twisted streets. Grand diagonal avenues provided efficient access to the city's significant sites – train stations, parks, the new opera house – and intersected in broad, open, starburst plazas (see pages 50–51). These changes made Paris a healthier, safer and more pleasant place in which to live, and in the process, as noted by the writer Théophile Gautier, the city donned 'its civilized attire'.[1]

Jules Cheret (1836–1932)
Fashion poster: *Grands Magasins
de la Ville de St Denis*, 1881
Colour lithograph
125 x 88 cm (49⅛ x 34⅝ in.)
Musée des Arts Décoratifs,
Paris

Commodious boulevards encouraged a new culture in the city. The streets became more than just the means to get from place to place, transforming into a destination in themselves. Describing life in contemporary Paris, writer Elie Frébault hailed the boulevard as the 'capital inside the capital', where fashionable Parisians, at their leisure, encountered friends and made acquaintances, but he cautioned that 'one no longer considers it a simple stroll'.[2] The *boulevardier* knew that he was under constant scrutiny by his fellow citizens; he – and she – dressed the part to make an appropriate impression.

The savvy stroller was fluent in the language of dress. With a fleeting look, he or she took stock of fellow passers-by (see pages 42–43). A man's ensemble announced his prosperity and his sense of purpose; impeccable tailoring and immaculate grooming exhibited respect for others as well as style. But a man also needed to wear his self-confidence as easily as his well-fitted suit, cloaking his carefully constructed image with an air of nonchalance (see pages 46–47). Smart women followed the fashions, but took care to adopt new silhouettes and accessories at just the right moment: while only the most daring wanted to be on the cutting edge of innovation, no one wanted to be left behind. Garments also served to signify social difference, seen for example in the contrast between the affluent man's frock coat and the worker's blue smock (see pages 12 and 48–49). But even those lines began to blur as ready-made, inexpensive versions of the latest styles allowed chic but cash-strapped women to appear as elegant as the more privileged – at least for the duration of a passing glance (see page 45).

Alfred Stevens
(1823–1906)

Departing for the Promenade (Will You Go Out with Me, Fido?)

Alfred Stevens won acclaim for his witty vignettes featuring stylish modern women. He had an eye for clever yet eloquent details; in *Departing for the Promenade*, the affluence of the household is indicated by the tastefully decorated room, with its gilded mouldings, silk settee and an elegant portrait in an ornate frame. The frisky white lapdog, eager to join its mistress on her stroll, announces that the woman is a lady of leisure, as cosseted as her petite pet. As part of his keen observation of the contemporary feminine scene, Stevens meticulously recorded current fashions. For a cold-weather walk, this woman has donned a loosely cut, fur-trimmed cloak, and a lace-trimmed bonnet tied with wide yellow ribbon and covered with a black fascinator.[3] And, for extra warmth, she has draped a large cashmere shawl over her shoulders.

Luxurious, richly coloured shawls woven from the hand-spun soft hair of mountain goats native to Kashmir were first imported into Europe in the late eighteenth century, when they served as a practical yet pretty wrap over the diaphanous neoclassical gown. By the time the wide crinolines of the French Second Empire brought them back into fashion, the term 'cashmere shawl' covered a range of wraps, from authentic imports to cheaply manufactured goods. As the circumference of skirts expanded, the shawls' size increased from about 1 sq. m (10¾ sq. ft), which had been popular in the early nineteenth century, to oblongs of up to 3.5 m (12 ft) in length. Whether Stevens's stroller wears a fine import or an imitation, her shawl has the right dimensions to make a fashionable impression on the street.

1859
Oil on panel
61.6 × 48.9 cm
(24¼ × 19¼ in.)
Philadelphia Museum
of Art

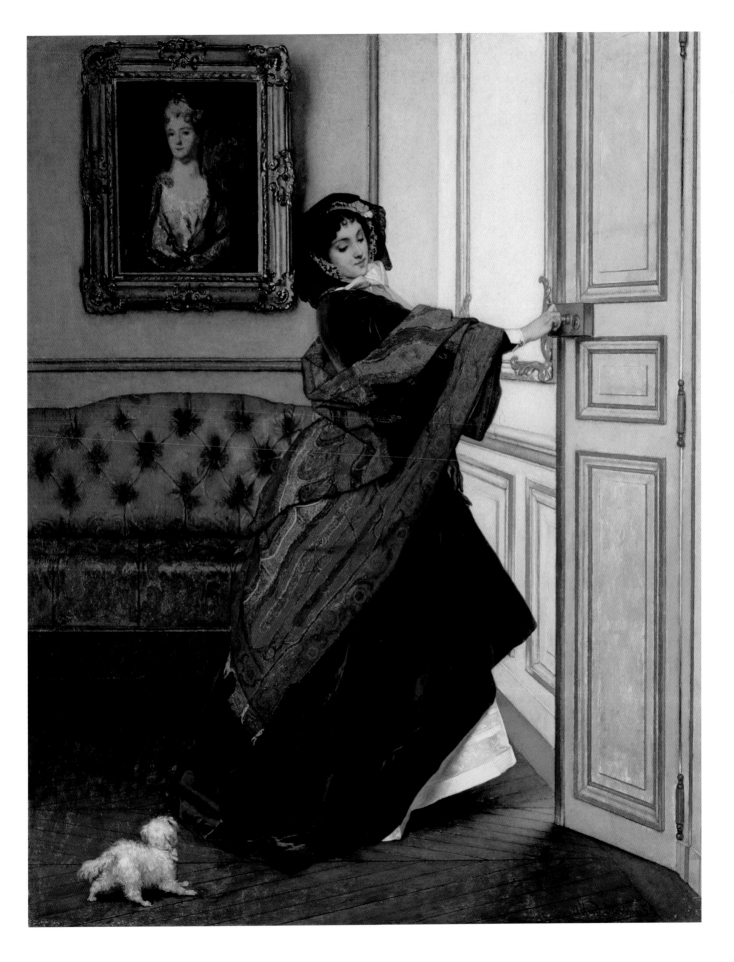

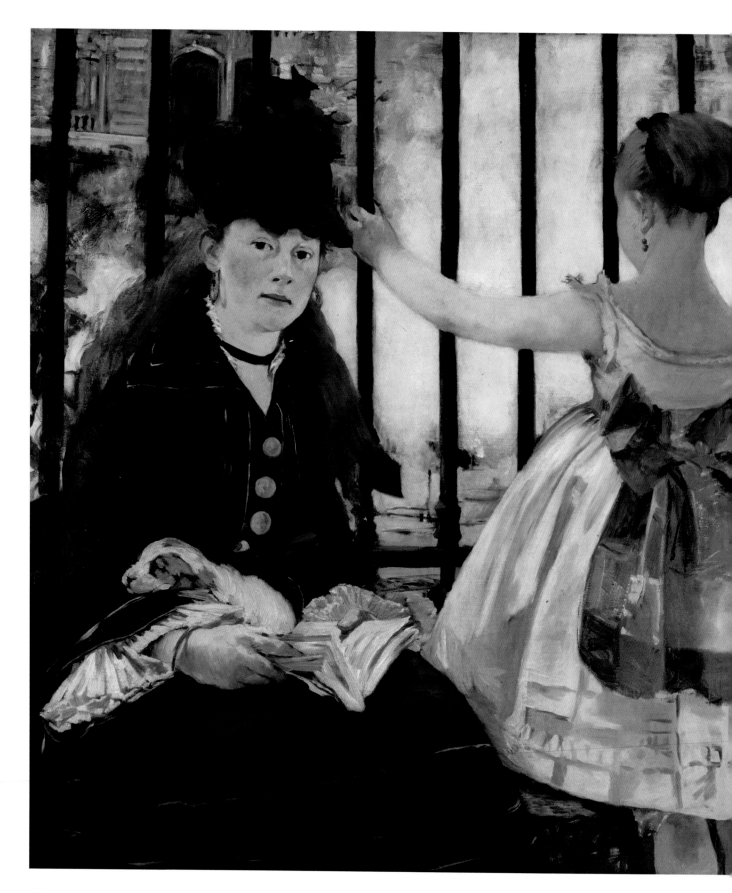

Édouard Manet
(1832–1883)

The Railway

1872–73
Oil on canvas
93.3 × 111.5 cm
(36¾ × 43⅞ in.)
National Gallery of Art,
Washington, D.C.

Édouard Manet set *The Railway* near the Pont de l'Europe, the then new iron bridge adjacent to Gare Saint-Lazare. The station opened in 1837 and soon became the busiest in France, providing the terminal for such popular day-trip destinations as Bougival, Argenteuil and Chatou. The imposing structures of the bridge and train shed engaged artists of Manet's circle. Gustave Caillebotte portrayed the bridge as a monumental feature of the modern cityscape (see pages 12 and 48–49), while Claude Monet captured the striking atmospheric effects in and around the station.[4]

Manet focused on the figures. Here, to establish Gare Saint-Lazare as backdrop for a woman reading with a young girl at her side, he presents no more than swirling grey smoke engulfing the rail yards and a glimpse of the bridge's grey girders on the right-hand edge of the canvas.

Writer Philippe Burty saw the work in progress in Manet's studio in September 1872 and described its subject as a woman 'wearing the blue twill that was in fashion until the autumn … sketched outdoors in the sun.'[5] The ensemble, worn by model Victorine Meurent, was a simple day dress with a loose jacket of the type that could be purchased ready-made (see also pages 130–31).

When the work appeared at the official Salon of 1874, many critics wondered why Manet had not depicted the trains.[6] The ambiguity of the relationship between the woman and the girl also troubled them. Manet was not painting an anecdotal scene, however; rather, *The Railway* captures the experience of a quick glance exchanged between a passer-by and an anonymous woman on the street as she looks up from her book.

Auguste Renoir
(1841–1919)

La Parisienne

1874
Oil on canvas
163.2 × 108.3 cm
(64⅜ × 42⅝ in.)
National Museum Wales

The pert and flirtatiously smiling model in August Renoir's *La Parisienne* fashionably embodies a distinctly modern charm.[7] Her walking ensemble is absolutely up to date: the *costume-tailleur*, featuring a tailored jacket over a matching multilayered skirt. The underskirt has a double flounce, while the top layer is drawn up and tied back, creating a gracefully draped front and amplifying the high profile of the *tournure* (bustle) at the back. The overall silhouette is both slender and extravagant, hinting at the curves of the model's body beneath the voluminous layers of her garments. Playful feminine touches soften the military-style lines of the double-breasted jacket: a soft bow and a frill of lace are seen above the officer's collar, and satin ribbons embellish the turned-back cuffs. Nearly every element of her ensemble, from the straw hat perched on the crown of her head to her tight leather gloves and the pointed toe of her boots, is dyed the same vivid blue.

The title of the painting, *La Parisienne*, refers to a contemporary type of frivolous, fashion-minded young woman, middle- or working-class, who used her looks as capital in an upwardly mobile society.[8] In Émile Zola's novel *Pot-Bouille* (1883), the young draper Octave Mouret, who has come to Paris to make his fortune, is attracted to his employer's shallow wife, Berthe, 'a Parisienne', an 'adorable creature' whose 'soft bosom is concealed by lace frippery'.[9] From her high-heeled boots to her tiny gloves, Berthe incarnated the modern woman, whose enticing mode of dress conveyed a material sensuality that merged fashion with desire.

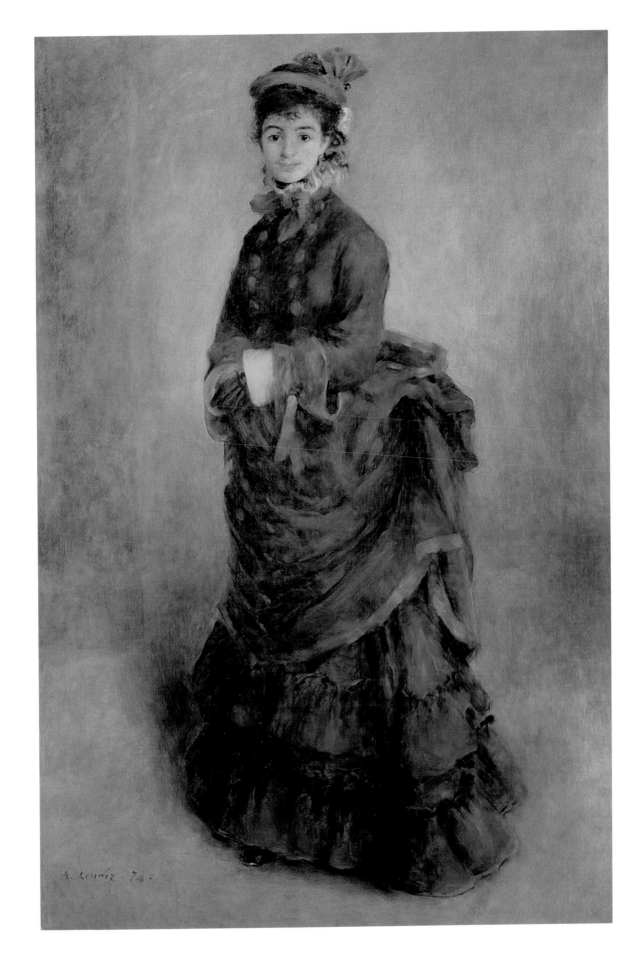

Edgar Degas
(1834–1917)

Place de la Concorde

Vicomte Ludovic-Napoléon Lepic, grandson of the Napoleonic general Louis Lepic, strides with purpose across the broad expanse of the place de la Concorde. An aristocrat in his bearing as well as by heritage, Lepic moves with confidence, his lean figure well displayed in an impeccably tailored frock coat. He is out for a stroll with his daughters, Janine and Elyau. As was the convention, the sisters dress identically; they are bundled against the chill in pearl-grey double-breasted coats and high-crowned black hats trimmed with soft feathers. Lepic was well known in many circles – as an art collector, a print-maker, a skilled horseman and a breeder of thoroughbred dogs – but in this depiction Edgar Degas emphasizes a singular achievement: the nonchalance of a modern urbanite.

The painting is infused with an atmosphere of immediacy and an air of tension thanks to Degas's radical approach to composition, which includes raked perspective, blank space and cut-off figures. But the action and the interplay of the people, emphasized by their garments, also contribute to these effects. Lepic's embodiment of sophisticated detachment is deliberate; it is as much a part of his public attire as the furled umbrella tucked under his arm, the cigar clenched in his teeth and the red ribbon of the prestigious Légion d'honneur order pinned to his left lapel. He is the perfect *boulevardier*. As he and his daughters cross the square, they catch the eye of a less stylish man in brown, who turns to stare at them. The girls are distracted; they pause in their father's wake, but Lepic moves on. His elegance arms him against the glare of public scrutiny.

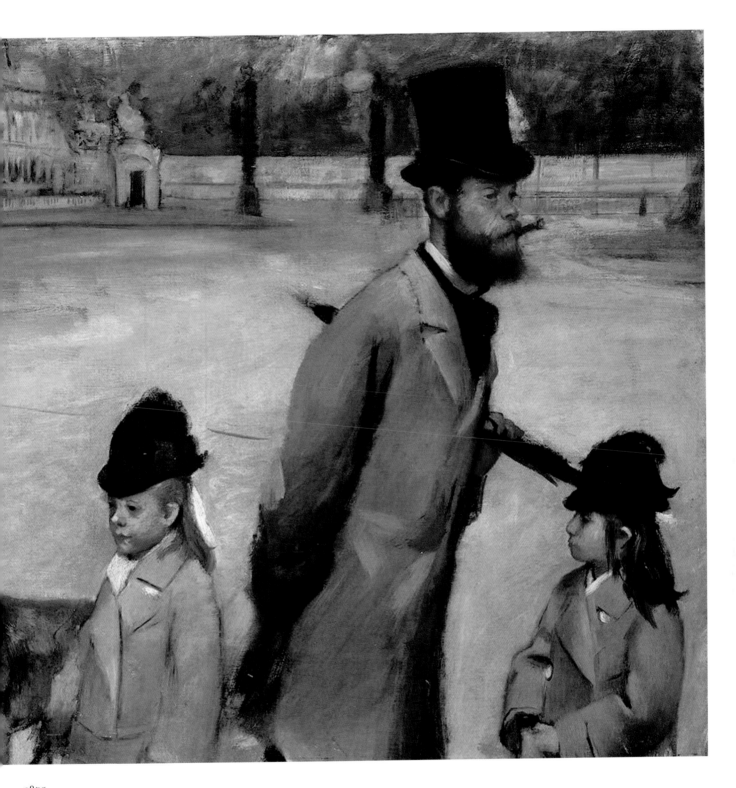

1875
Oil on canvas
78.4 × 117.5 cm
(30⅞ × 46¼ in.)
The State Hermitage
Museum, St Petersburg

Gustave Caillebotte
(1848–1894)

On the Pont de l'Europe

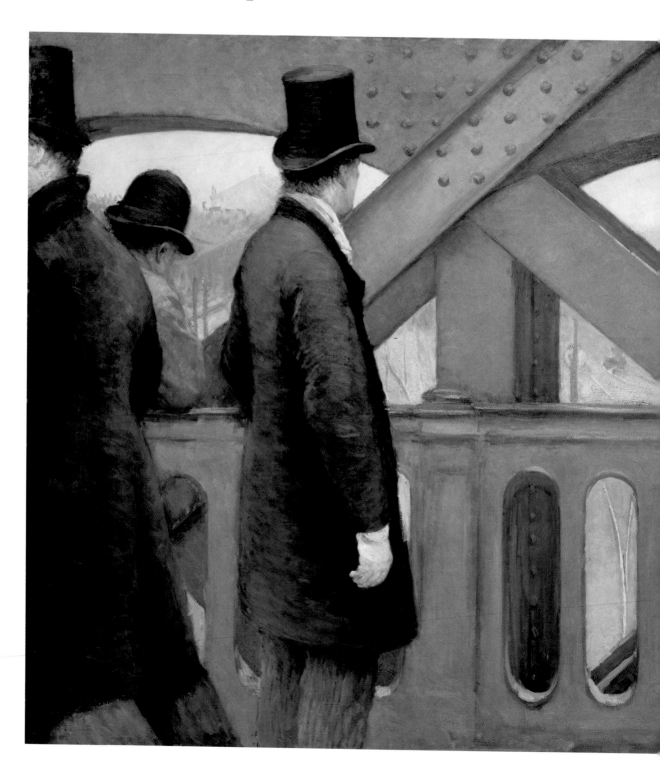

1876–77
Oil on canvas
105.7 × 130.8 cm
(41⅝ × 51½ in.)
Kimbell Art Museum,
Fort Worth, Texas

The poet Charles Baudelaire described the true urbanite as a 'passionate spectator', moving through the city incognito but alert to every change in his surroundings.[10] The anonymous figure at the centre of Gustave Caillebotte's painting *On the Pont de l'Europe* has found the perfect place from which to conduct his casual surveillance: the new bridge over the rail yards of the Gare Saint-Lazare. Built between 1865 and 1868, the Pont de l'Europe was regarded as a marvel of modern engineering; in his novel *La Bête Humaine* (1890), Émile Zola described it as an 'iron star' that 'cut across open space'.[11] And its site – at the intersection of six new avenues – presented a thoroughly modern panorama, prompting passers-by to stop and peer through the massive cross braces at the train shed in the distance and the tracks below.[12]

Caillebotte's spectator is a man of some means, as can be seen in his smartly tailored ensemble: a brushed top hat, a well-fitted frock coat, and immaculate scarf and gloves. He embodies the spirit of Baudelaire's *flâneur*, a man about town who blends into the crowd. Another man, similarly dressed, has just passed by. Behind him, to the spectator's left, is a man in a blue smock, the uniform of the building trades. But rather than a workman's cap, he wears a bowler hat, indicating that he, too, can afford a few luxuries. All three men belong to the middle classes, but the details of their garments indicate their social rank. The urbane spectator would be fluent in this code; fashion added insight to his leisurely observations.

Gustave Caillebotte

(1848–1894)

Paris Street; Rainy Day

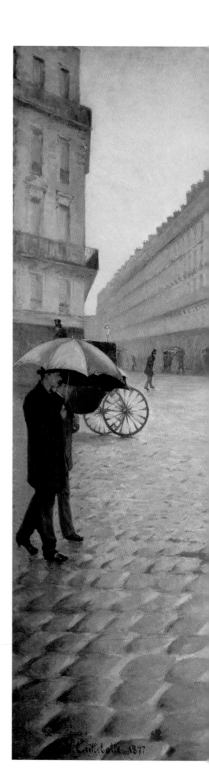

Under Georges-Eugène Haussmann's urban regeneration plan, the narrow, tangled streets of old Paris were replaced with broad, open avenues. Visiting in 1867, American writer and critic Henry Tuckerman noted that the 'vista of new streets', flanked by recently built and renovated façades, created an aspect that was as 'progressive' as it was 'commodious'.[13] The setting for Gustave Caillebotte's *Paris Street; Rainy Day* – the convergence of the rue de Saint-Pétersbourg, the rue de Turin and the rue de Moscou near his family's residence – depicts the distinctive starburst intersection as just such a stage for contemporary life.

In preparation for the painting, Caillebotte repeatedly sketched the location, mapping out the perspective of the buildings and the axes of the pavement-lined avenues. He was just as meticulous in sketching the pedestrians, keenly observing their movements and gestures, as well as the features of their costume.[14] He drew the couple in the right foreground from many different angles in order to catch exactly how the man thrust his hand in his overcoat pocket and how the woman lifted the bottom of her skirt off the damp pavement.

Caillebotte's silver-grey palette is as understated as the uniformity of the men's formal daywear, which varies in tone rather than in style or colour. Urban life imposes anonymity; even the umbrellas are all the same. There is no story to tell, but, with the sharp eye of a *flâneur*, Caillebotte finds delight in the details: the shine on wet silk; the drape of a well-cut garment; and the gleam of the luminous pearl earring worn by the woman in her modest walking costume of slim skirt and fur-trimmed *paletot* jacket.

1877
Oil on canvas
212.2 × 276.2 cm
(83½ × 108¾ in.)
The Art Institute of
Chicago

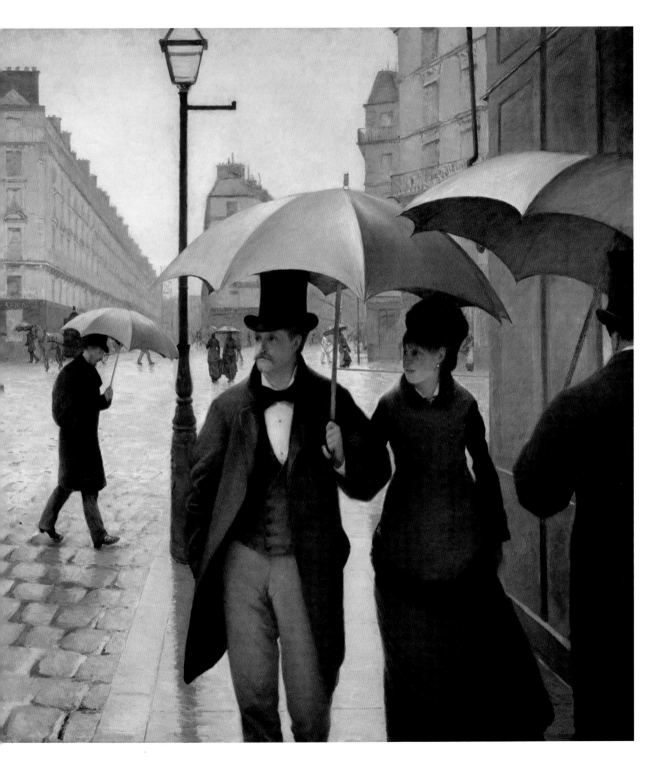

Édouard Manet
(1832–1883)

Woman Reading

1879–80
Oil on canvas
61.2 × 50.7 cm
(24⅛ × 19⅞ in.)
The Art Institute
of Chicago

For the price of a beverage, a man could secure a comfortable table at a café and while away the afternoon, making pleasant conversation with friends or strangers while watching other habitués come and go at their leisure. But a woman on her own had to be more circumspect. A woman without a companion was subjected to stares and suspicion. Why was she alone? Was she meeting her husband or was she engaged in a romantic tryst? In *Woman Reading*, Édouard Manet offers a solution to such unwarranted attention: a woman could shield herself from prying eyes with a newspaper borrowed from the rack kept on the premises for patrons' convenience.

The setting is believed to be the Café de la Nouvelle Athènes in place Pigalle, where Manet regularly met his friends. In accordance with conventional propriety, the woman wears a full street ensemble, including a black brimmed hat and fawn leather gloves. The sunlit flowering landscape behind her suggests that she is on a terrace or in a patio garden, but her bulky coat and commodious hat reveal that she is dressed for winter. The backdrop is more likely to be a mural or a pictorial hanging. And it is unlikely that Manet worked at this location; he probably staged the scene in a studio.[15] The details are absolutely authentic, however, from the *demi* (small beer) on the adjacent table to the wooden rod inserted along the fold of the illustrated journal that marks it as being the property of the café.

Auguste Renoir
(1841–1919)

The Umbrellas

c. 1881–86
Oil on canvas
180.3 × 114.9 cm
(71 × 45¼ in.)
The National Gallery,
London

In *The Umbrellas*, Auguste Renoir shows that even a sudden downpour did not still the commotion on the busy streets of Paris. Under a canopy of hoisted umbrellas, businessmen move with purpose, a chic mother strolls with her daughters, and a rakish fellow in a brown coat and black gloves casts an admiring glance at a woman in a form-fitting cuirass jacket. Although the lines of the woman's garments are fashionable, her bare head and hands, as well as her market basket, identify her as a servant. In contrast, the mother wears a mantlet over her walking costume; blue leather gloves and a feather-trimmed hat complete her ensemble. The girls' short coats reveal skirts and lace-trimmed petticoats over matching stockings, and their bonnets are lavishly trimmed with ribbons, ruffles and bows. But the girls have something in common with the servant: they do not have umbrellas.

The waterproof umbrella had been known in Europe since the late seventeenth century. Umbrellas were handmade, with a wooden or baleen (whalebone) frame, and often featured ornamental carvings on the handle. But in the 1850s, manufactured steel-framed umbrellas made fine craftsmanship nearly obsolete.[16] This is voiced in the complaints of a cantankerous umbrella-maker in Émile Zola's novel *Au Bonheur des Dames* (1883). Old Bourras took pride in his work, finishing off each handle with 'charming inventiveness', but now that department stores stocked mass-produced goods, he raged that 'The craft is finished.'[17] The plain handles of the umbrellas in Renoir's painting give credence to his statement.

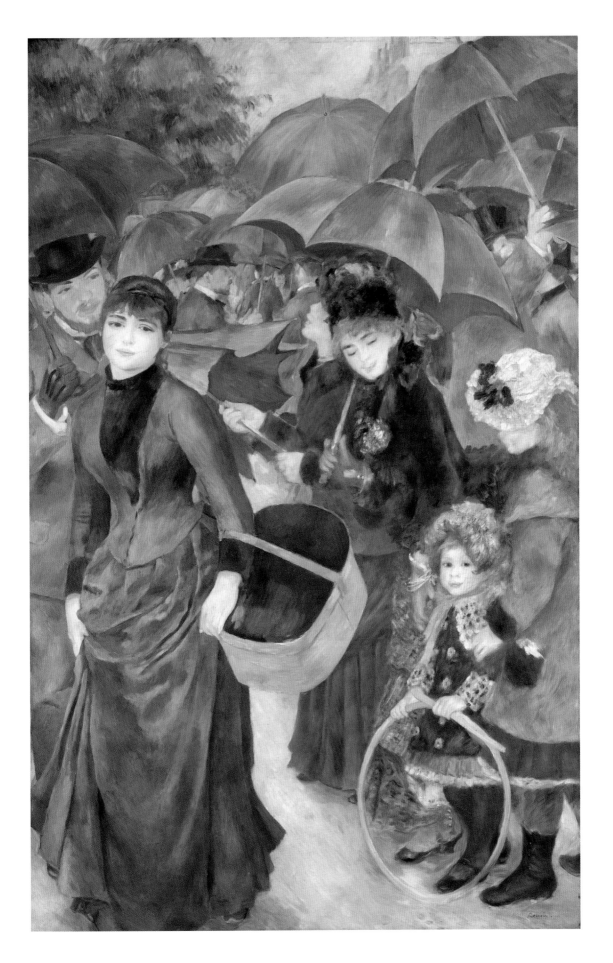

INTERLUDE
The Maison de Couture

Attrib. to François-
Benjamin-Maria Delessert
(1817–1868)
*Empress Eugénie and the
Prince Imperial*, 1862
Albumen print from glass
negative
The Metropolitan
Museum of Art, New York

British-born Charles Frederick Worth (1825–1895) began his career in French fashion in 1846 as a draper's assistant at Gagelin et Opigez, one of the finest silk mercers in Paris. He excelled at his work, and over the years he convinced his employers to institute a number of innovations, most notably the introduction of a small dressmaking department in 1853. The concept was such a success that Worth sought to expand the service and to feature his own designs. Five years later he teamed up with Otto Bobergh to open a *maison de couture* that provided complete dressmaking services, from consultation to materials, construction and custom-fitting. Thanks to distinctive original designs, luxurious fabrics and the highest standard of quality in all aspects of fabrication, Worth et Bobergh quickly became the premier establishment in the fashion industry.

Worth et Bobergh offered much more than a consolidated venue for dressmaking; a visit was a grand experience. Clients relaxed in a luxurious showroom, where they reviewed designs with an attentive *vendeuse* (sales assistant), consulted with specialists in the various fabric and trim departments, and enjoyed the novelty of live mannequins modelling ensembles. Teams of seamstresses worked on the premises in two divisions: *flou*, traditional dressmaking; and *tailleur*, featuring the structured techniques associated with men's tailoring. Above all, the establishment had its creative director, Worth himself, who provided the designs and offered private consultations for the top tier of his clientele. This, by 1860, included Empress Eugénie and her friend Princess Pauline von Metternich, the wife of the Austrian ambassador to the French court (see page 125).

Worth's signature designs were sumptuous yet elegant, as seen in the silk ensemble (right). The full skirt, embellished with tiers of ruffled and petal-scalloped flounces, has a modified bell shape. To keep fashion looking fresh – and in flux – Worth constantly modified silhouettes and style lines. Here the skirt front is flatter than the sweeping back, which is exquisitely emphasized by the flounces and the huge bow with trailing sashes. A photograph of the Empress with her son (opposite) reveals that she owned a similarly trimmed ensemble. The dress came with two different corsages: one long-sleeved and simply cut for day wear, and the other with a deep décolletage, short sleeves and gold tulle trim for evening.

Worth launched trend after trend, from small rakish hats to the elimination of crinolines and the development of the princess line. But his greatest innovation was in succeeding as a man in a woman's profession, and in the process redefining an artisanal skill as a creative art. Within a few years competing houses were opened by other designers, including Emile Pingat in 1860 and Jacques Doucet in 1871, and in his novel *La Curée* (1872), Émile Zola portrayed a dictatorial couturier known as the 'illustrious Worms'. Bobergh left the house in 1871; after Worth's death his sons and then his grandson oversaw the business until 1954, when it merged with the House of Pacquin; this ceased trading in 1956.

French School
The Couturier, 1899
Colour lithograph
Bibliothèque des Art Décoratifs, Paris

Charles Frederick Worth (1825–1895)
Evening ensemble, 1862–65
Silk
The Metropolitan Museum of Art,
New York

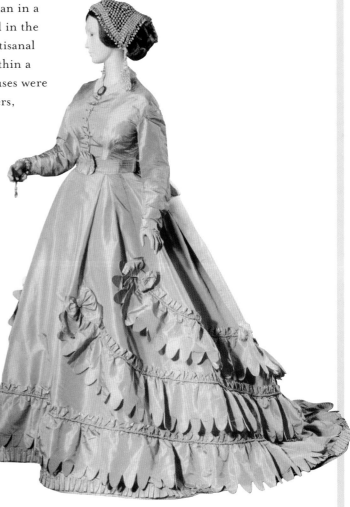

At Home

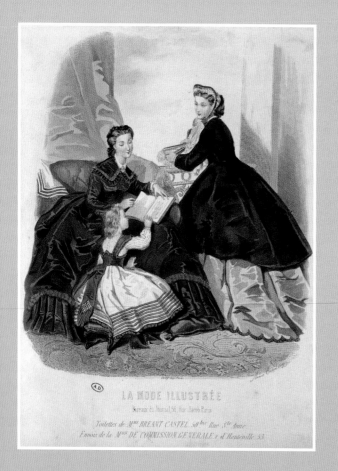

LA MODE ILLUSTRÉE

The publisher Georges Charpentier and his wife, Marguerite, frequently hosted gatherings of artists and writers in their home on the rue de Grenelle. Their reception rooms, located on the first floor, directly above Charpentier's office, were well known for their extravagant Japanese decor, yet when Auguste Renoir's portrait of Marguerite and the children (pages 70–71) appeared in the Salon of 1879 some of their closest friends were puzzled by the setting. Although the room was decorated with screens and porcelains, it seemed less cluttered, unfamiliar. The poet Théodore de Banville claimed that it was a smoking room off the regular reception area, but the writer Philippe Burty, who had advised the Charpentiers on acquiring their Japanese treasures, recognized it as the snug salon adjacent to Marguerite's boudoir.[1] Little wonder that their guests had never seen it; Renoir had set the portrait in one of the household's most private spaces.

Whether small suites of rooms in apartment blocks or large multi-storey mansions, middle-class Parisian

Anais Toudouze (or Adele
Anais Colin; 1822–1899)
Fashion plate showing
clothes designed by
Madame Breant-Castel,
from *La Mode Illustrée*, 1864
Colour engraving
Archives Charmet,
Bibliothèque des Arts
Décoratifs, Paris

homes accommodated both semi-public and private life. Keeping separate rooms in which to entertain allowed a ftamily to control and insulate the intimacy of a household; it was unlikely that guests who were regularly welcomed into a grand salon or a cosy parlour would ever see the interior of a dressing room, let alone that of a boudoir.

Just as there was a different etiquette for various spaces, clear dress codes set the tone for social decorum and defined the difference between guest and host. For an afternoon visit – mornings were always private – the correct choice was formal daywear. Female guests wore their hats (see page 72), but men removed theirs as soon as they crossed the threshold (see pages 74–75). Men of the household dressed exactly like their male guests, but hostesses wore gowns exclusively designed to be worn at home. The ensemble worn by the lady of the house was distinguished from street wear by its delicate fabrics, lighter colours and, often, a touch of whimsy or

exotica that would be inappropriate in public, reminding guests that they had passed from the public to the private domain (see page 61).

Some garments were never meant to be seen beyond the confines of the boudoir (see page 63). On rising out of bed, men would immediately cover their nightshirt, and women their negligees, with dressing gowns and peignoirs, and these were rarely worn outside the dressing room (see pages 65 and 67). Even though Marguerite Charpentier allowed Renoir to depict her in her private sitting room, she dressed in an elegant gown, fine enough to be worn to welcome guests into her salon. Anything less would have transgressed the barrier between the family's personal life and their social circle.

Claude Monet

(1840–1926)

Madame Louis Joachim Gaudibert

In the early autumn of 1868 Claude Monet painted a portrait of Marguerite-Eugénie-Mathilde Gaudibert, the wife of a wealthy merchant from Le Havre.[2] Monet rarely received commissions for portraits, and his approach was highly unconventional. Instead of positioning his sitter so that he could feature her likeness, Monet had her turn away from the viewer, revealing only a lost profile. Yet the portrait conveys a distinct identity. In her fashionable afternoon dress, with its sweeping train and velvet trimmings, Madame Gaudibert embodies her role as a woman of means who gracefully presides over an affluent household from her well-appointed parlour.[3]

The cut of Madame Gaudibert's heavy silk gown is modest but not conservative. The skirt, supported by a narrow understructure (visible in Monet's depiction in the vertical, paler-toned ridge in the fabric), responds to the new slender silhouette popularized by the couturier Charles Frederick Worth (see pages 56–57); he eliminated crinolines from his designs altogether the year after this portrait was painted. Madame Gaudibert's corsage is simply cut and tightly fitted. Its severity is decorously countered with a small lace fichu at the neckline and bands of black velvet, and a trail of matching bows embellishes the front of the skirt. The ensemble indicates that Madame Gaudibert was spending the afternoon at home: the ample train would have needed to be looped up for walking, and, by 1868, no fashionable woman would wear a cashmere shawl on the street, even such a magnificent example as this one.[4] The painting's emphasis on the costume may explain the sitter's unorthodox pose, which reveals the influence of fashion plates. In Monet's portrait, Madame Gaudibert is defined by her marvellous clothes.

1868
Oil on canvas
216.5 × 138.5 cm
(85¼ × 54½ in.)
Musée d'Orsay, Paris

Édouard Manet

(1832–1883)

Young Lady in 1866

In an essay on Édouard Manet's career published in 1867, Émile Zola took special note of a newly painted work that revealed the artist's 'innate stylishness'.[5] Zola explained that the painting he called *The Woman in Pink* struck an extraordinary balance between the subject's inherent charm and Manet's own characteristic severity. The subject matter was at once straightforward and enigmatic: a woman standing next to a parrot perched on a stand.[6] She holds a delicate cluster of violets in her right hand; with her left, she fingers the chain of a monocle.[7] Zola made no attempt to explain these features; instead, he singled out the pink dressing gown as being 'exceedingly elegant' and declared that the work was 'one of the best things the artist has done'.[8]

Dressing gowns were informal garments worn over nightclothes or lingerie to ensure modesty; they were simply cut, made of substantial fabric, and sparely embellished. The woman in Manet's painting is swathed in heavy silk that seems all the more luminous against the dark, neutral background. Large buttons close the gown, but a bit of lace at the opened neckline hints at a more provocative garment worn beneath it. Her hair is plainly dressed, and, other than the monocle, her only ornament is a golden medallion strung on a black velvet ribbon. Through these details, Manet's audience would have recognized immediately that the woman was in her dressing room or boudoir. As Zola observed, this was more than an image of a beautifully dressed woman; it was a bold look at modern private life.

1866
Oil on canvas
185.1 × 128.6 cm
(72⅞ × 50⅝ in.)
The Metropolitan
Museum of Art, New York

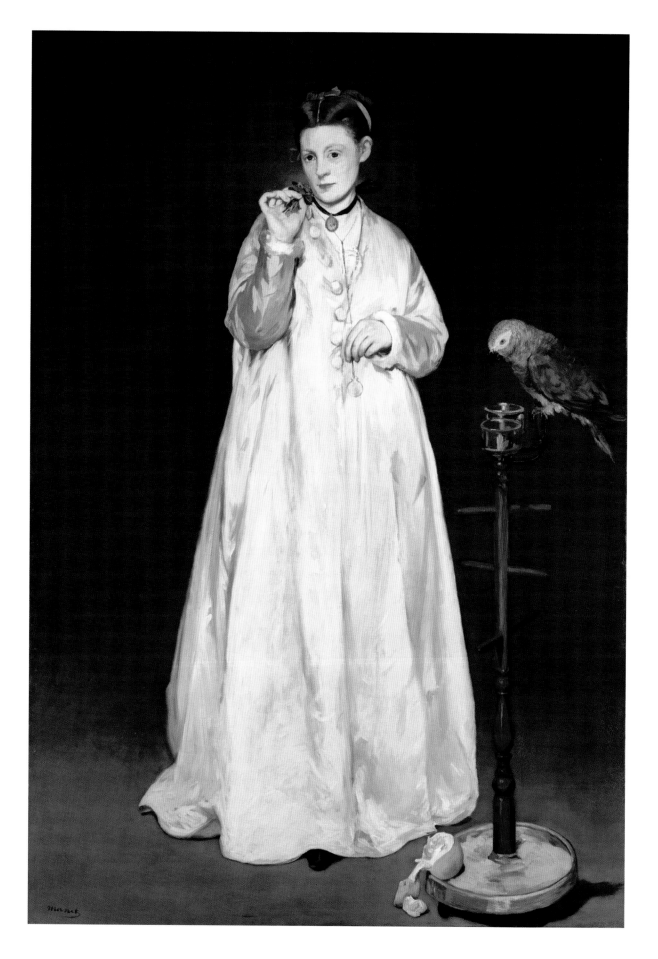

Auguste Renoir
(1841–1919)

Portrait of Rapha

Paris was under siege in April 1871, when Auguste Renoir was demobilized from military service. Rather than bringing peace to the city, the end of the Franco-Prussian War had ignited civil insurgence as factional forces grappled to seize power in the wake of the Second Empire. Riots and sniper fire were continuous throughout the brief regime of the radical Paris Commune (18 March–28 May), so businesses remained shuttered and wary citizens stayed in their homes. This portrait, commissioned by civil servant Louis-Edmond Maître of his mistress, Rapha, was the first work Renoir completed on his return.[9]

The iron birdcage, with its green and white budgerigars, is often seen as a metaphor for Rapha's situation, safe yet imprisoned behind locked doors. Her garments also signify that she will remain at home. She wears a magnificent peignoir, composed of a short yet amply cut dressing jacket trimmed at the hem and cuff with bands of ruching and lace, and a matching double skirt with a deep, pleated train.

The origin of the word 'peignoir' is *peigner*, 'to comb', and this type of dressing gown evolved from the loose jacket or mantle that a woman wore to protect her clothes as her maidservant dressed her hair. By the middle of the nineteenth century, both peignoirs and dressing gowns were worn at home when a woman was not fully dressed. Although the terms were used interchangeably, dressing gowns tended to be plainer and worn for warmth, while peignoirs were made of materials chosen for their beauty, and were styled and trimmed in the latest mode.

1871
Oil on canvas
130 × 83 cm
(51¼ × 32⅝ in.)
Private collection,
Switzerland

Berthe Morisot
(1841–1895)

The Artist's Sister at a Window

Late in 1869, as her pregnancy advanced, Edma Morisot-Postillon, Berthe Morisot's older sister, returned to live with her mother in her childhood home in the well-to-do suburb of Passy. It was typical for affluent women in her condition to retreat from public view, and in this portrait Morisot conveys the benign state of isolation that a privileged woman experienced as she waited for the birth of her child.

Edma wears a lace-trimmed peignoir. Its voluminous silhouette, finished with a deeply flounced hem, was intended to accommodate rather than disguise her expanding proportions. When worn by women who were not pregnant, peignoirs were restricted to the boudoir; if the Morisot family followed bourgeois decorum, only family members and intimate friends would see Edma at this time. Her hair is loose, but it is not unkempt; it has been dressed into long curls and tied back over her shoulders with a simple ribbon. Her gesture betrays the boredom induced by her circumstances; rather than looking at the lovely view, she absently toys with a fan.

In terms of fashion, the pregnant consumer was not completely neglected. Special corsets, modestly marketed for 'the young matron', were available.[10] And a decade after Morisot painted Edma, the writer and publisher Edmond de Goncourt recorded in his journal that he had seen an unusual and intriguing display at the House of Worth (see pages 56–57): a live mannequin in 'an interesting condition', seated 'all alone, in the half-light of a boudoir', exhibiting the designer's 'genius for compensating for the ungainly appearance of being with child'.[11]

1869
Oil on canvas
54.8 × 46.3 cm
(21⅝ × 18¼ in.)
National Gallery of Art,
Washington, D.C.

Édouard Manet
(1832–1883)

The Monet Family in Their Garden at Argenteuil

On a sunny day in July 1874, Édouard Manet painted Claude Monet and his family in the garden of their rented home in Argenteuil, north-west of Paris. Monet later recalled that Manet, 'enthralled by the colour and the light', set up his easel on the spot to capture the exact effects of natural illumination on the figures relaxing in the shade of the tree.[12] Manet usually worked in the studio, but Monet had urged him to work outdoors, and this charming, informal portrait has the spontaneous quality, high colour and nimble touch associated with Monet's own *plein-air* (open-air) approach.

The comfortable clothes worn by Monet's wife, Camille, and her son appear in other paintings of family life that the artist had made the previous summer.[13] Camille's dress is made of a fine, lightweight cotton, most likely treated with a starched glaze so that it would hold its crisp shape in the heat

and humidity. Like most boys his age, seven-year-old Jean spends his summer in a loose-fitting sailor suit. His legs are bare, save for short stockings, and his shoes have red laces that match the band on his soft straw hat. Camille's hat is a stylish confection of white tulle, pink flowers and black ribbons; its forward tilt, a style launched by the designer Charles Frederick Worth (see pages 56–57), reveals her elaborate chignon.[14]

Auguste Renoir also turned up that day, and he painted the same scene of the pair from a slightly different angle.[15] But Manet's painting also includes Monet, in shirtsleeves and sun hat, busily tending his garden.

1874
Oil on canvas
61 × 99.7 cm
(24 × 39¼ in.)
The Metropolitan
Museum of Art, New York

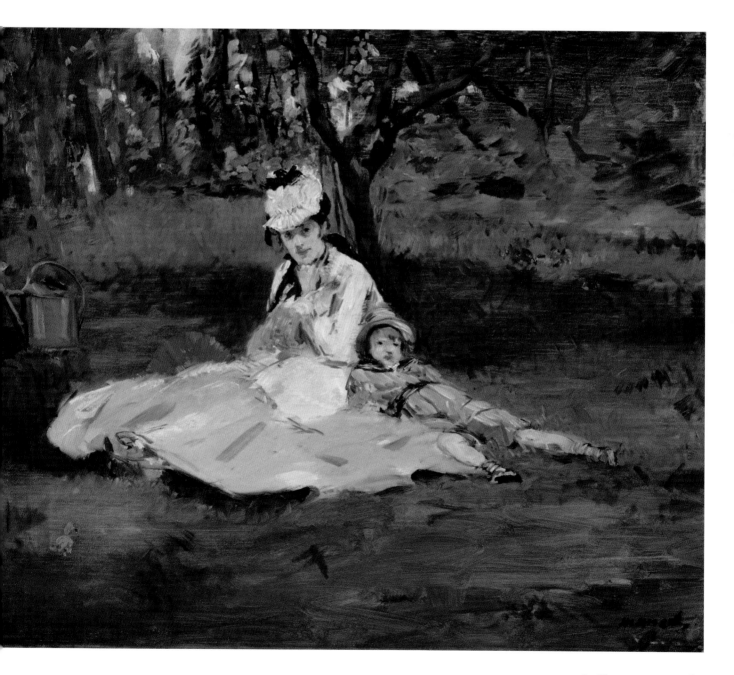

Auguste Renoir
(1841–1919)

Madame Georges Charpentier and her Children

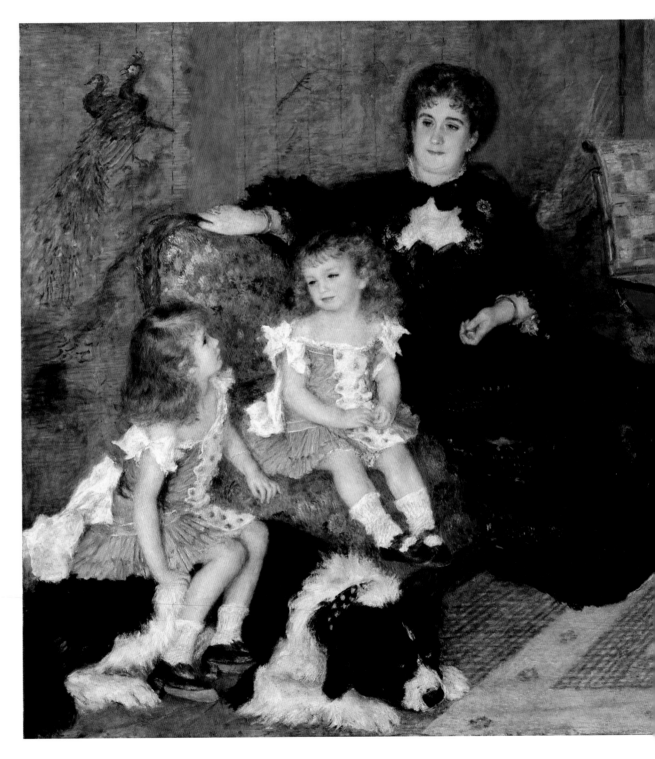

1878
Oil on canvas
153.7 × 190.2 cm
(60½ × 74⅞ in.)
The Metropolitan
Museum of Art, New York

When Marguerite Lemonnier married publisher Georges Charpentier in 1871, she entered his circle of progressive artists and writers. Charpentier successfully produced novels of modern-day life, and in 1876 he moved both his business and his family into a large residence on the smart rue de Grenelle.[16] Madame Charpentier quickly earned her own reputation as a generous patron and hostess of a lively salon; gatherings were held in tasteful reception rooms, decorated in the fashionable Japanese style, above the publishing office.

Auguste Renoir had already painted several family portraits, but this one has an unprecedented air of intimacy. The setting, a little Japanese salon, was adjacent to Madame Charpentier's boudoir. The children wear matching blue dresses and have flowing hair with a short, clipped fringe: daughter Georgette sits on Porthos, the family's docile Newfoundland; son Paul sits next to his mother on the divan (it was typical to dress small boys in the same way as their sisters until they reached the age of four or five).

Madame Charpentier's black silk day dress, designed by Charles Frederick Worth (see pages 56–57), features a distinctive balance of modesty and luxury. A lavish lace ruffle peeks out from under the hem, and the lace of a white *guimpe* (under blouse) relieves the severity of the corsage. She has pinned a little daisy brooch – a play on her name, Marguerite – to her shoulder. Although the portrait is intimate in tone, it had an important debut at the Salon of 1879, and Renoir recalled that Madame Charpentier used her considerable influence to guarantee that the painting was hung to her satisfaction.[17]

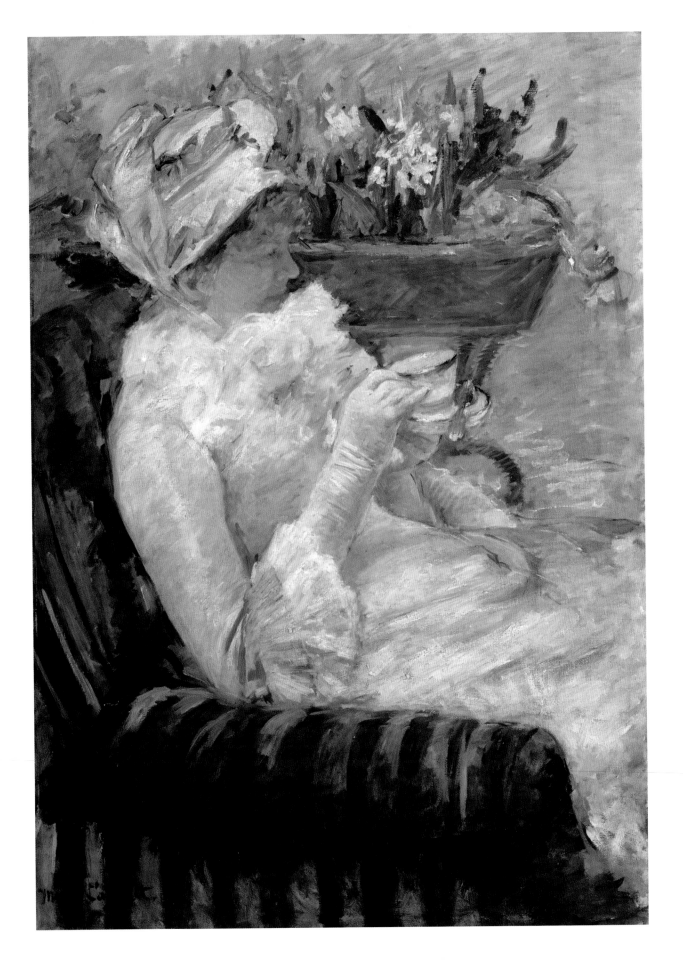

Mary Cassatt
(1844–1926)

The Cup of Tea

1879
Oil on canvas
92.4 × 65.4 cm
(36⅜ × 25¾ in.)
The Metropolitan
Museum of Art, New York

In London, New York and Philadelphia, middle-class women paused mid-afternoon to chat over tea with friends and family, and the American-born Mary Cassatt regularly entertained guests in this fashion in her Paris apartment. Her circle included such American visitors as the Alcott sisters, novelist Louisa and artist May, and the lively conversation focused more on literary and artistic ideas than on gossip. Anglo-American etiquette was stricter than that guiding more relaxed Parisian social practices, and the attire worn by the woman taking tea in Cassatt's painting illustrates some of these rules.

A visit was meant to be brief; no woman wanted to offend her hostess by overstaying her welcome. To prove this point, a woman did not remove her hat or her gloves. Dressing well was a compliment to the hostess, and the woman depicted here wears a stunning ensemble of pink silk trimmed with filmy yet voluminous white lace. No doubt she carried a matching pink silk parasol. The gown features the slim and fashionable princess line developed as a daywear silhouette by Charles Frederick Worth (see pages 56–57) for the tall and slender Alexandra, Princess of Wales, and is tapered to the body without a seam at the waist (see also pages 86–87).

Cassatt enjoyed fine clothes, and she was a regular customer at the premier couture houses in Paris. Just as her paintings reflected the life she knew, the garments in her paintings were as fashionable as those in her own wardrobe, so much so that one American journal described her hallmark subject matter as 'the Modern Woman glorified by Worth'.[18]

Édouard Manet

(1832–1883)

In the Conservatory

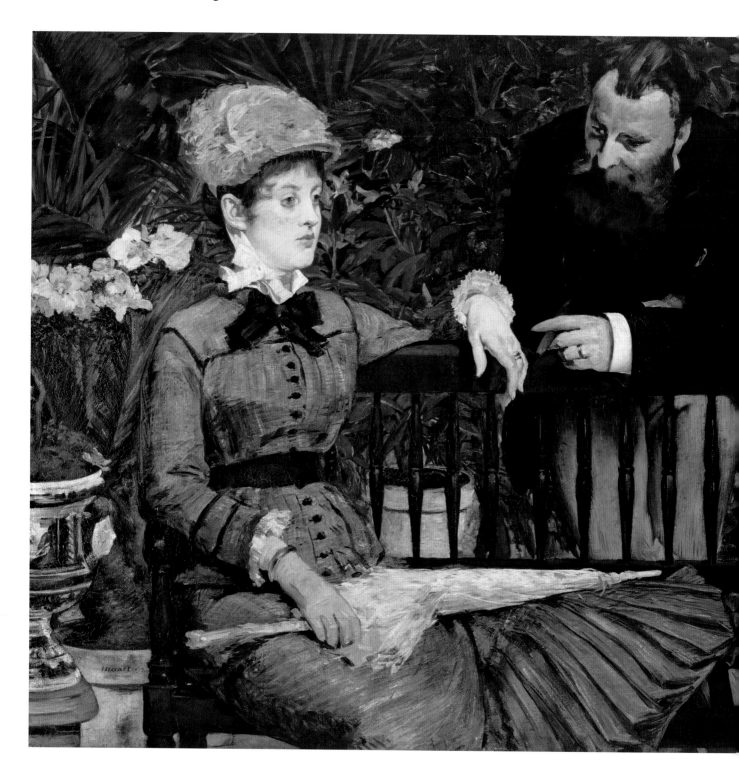

1879
Oil on canvas
115 × 150 cm
(45¼ × 59 in.)
Alte Nationalgalerie,
Staatliche Museen
zu Berlin

The conservatory developed from the same advances in iron and glass technology that allowed Second-Empire architects to span vast spaces for train sheds and exhibition halls. But, when attached to the drawing room of a wealthy residence, it was a purely private space where a family and their privileged guests enjoyed the heady pleasures of tropical heat and exotic plants throughout the year. In his novel *Bel-Ami* (1885), Guy de Maupassant described the sensuous delights of scented air and the 'silvery shower' of light filtering through towering palms as 'captivating, artificial, soft and enervating'.[19]

The details of dress in Édouard Manet's *In the Conservatory* reveal that this fashionable couple are visitors. Madame Guillemet wears her hat and retains her gloves and parasol. Her husband, Jules (note that they are both wearing wedding rings), has taken off his hat; he would not have done so in a public garden. His garments are conventional informal daywear, while hers are absolutely up to date. The silhouette of her superbly fitted grey ensemble is columnar, as dictated by the 'long-limbed line' (see also Auguste Renoir's *The Swing*, page 87). Made of shimmering blue-grey silk, the outfit is modestly but exquisitely embellished with buttons fastening the jacket, a high-waisted belt and a pert bow, all in midnight-blue. The pleated flounce at the hem of the skirt marks the garment as a walking costume; with it, the slim cut of the ensemble would not impede Madame Guillemet's natural gait. Her stylish appearance is not surprising: with her husband, this American-born Parisian owned an elegant clothes shop on the rue du Faubourg Saint-Honoré.[20]

John Singer Sargent
(1856–1925)

Dr Pozzi at Home

For many men, the only flash of colour in their wardrobe was a dressing gown. Based on robes worn by men in Asia and North Africa, dressing gowns were often made from such flamboyant fabrics as patterned silk or woollens, and paired with such oriental accessories as the fez-shaped smoking cap and embroidered slippers. The garment was worn in private; it was the first thing a man put on over his nightshirt when he rose in the morning, and the last thing he removed when he prepared for bed. Associated with the boudoir, the bathroom and the dressing room, the dressing gown would be seen only by a man's most intimate companions: his valet, his wife and, perhaps, his mistress.

Posing for a portrait in his dressing gown, Dr Samuel-Jean Pozzi showed his disdain for decorum. A general surgeon who specialized in gynaecology, Dr Pozzi had a reputation as a learned bibliophile and discerning art collector. He was tall, with a commanding physique and brooding good looks, and enjoyed notoriety for his romantic conquests, including the actress Sarah Bernhardt, who nicknamed him 'Doctor Dieu' ('doctor God').[21] With his left hand fingering the cord that closes his gown, Dr Pozzi willingly inhabits the role of seducer.[22]

John Singer Sargent made the most of his sitter's swagger and dramatic appearance by emulating the portrait type developed by Diego Velázquez (1599–1660) for the seventeenth-century Spanish court. But whereas Velázquez had employed a restrained palette of black, grey and silver to enhance his sitters' dignity, Sargent proclaimed Pozzi's innate sensuality in vivid hues.

1881
Oil on canvas
202.9 × 102.2 cm
(79⅞ × 40¼ in.)
Hammer Museum, UCLA,
Los Angeles

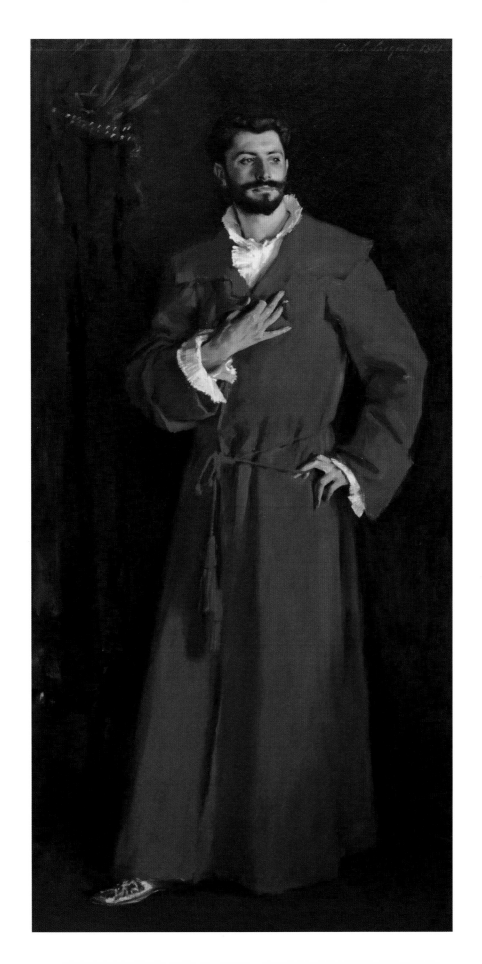

INTERLUDE

At the Department Store

In 1852 Aristide Boucicaut (1810-1877) forged a partnership with Paul Videau, the owner of the shop Le Bon Marché; by 1863, when Boucicaut bought out his partner, he had transformed the Bon Marché into an emporium unlike any other in Paris. Boucicaut conceived his establishment as a *grand magasin* with departments featuring every type of dry goods and notions for wardrobe and household use. Since the early years of the century, such stores as Au Paradis des Dames (opposite, right), known as *magasins de nouveautés* (novelty shops), had offered a limited selection of accessories and trims to complement their stock of fabric. But Boucicaut imagined shopping on an unprecedented scale: one stop for everything, with attractive departments, staffed by expert clerks ready to cater to the female shopper's every need. Under a single roof and in just one afternoon, a customer could select a pattern from a catalogue of the latest fashions; consult with a draper; choose the trims, from buttons to lace; have her measurements taken and her order placed; and then select accessories – gloves, hats, parasols, stockings, shawls – to complete her new ensemble. Shopping had never been so easy or so attractive.

With his *grand magasin*, Boucicaut transformed shopping from a mundane necessity into an exciting experience. Unlike boutiques, which a customer did not enter unless she had planned a purchase, the Bon Marché became a haven for browsers. Boucicaut recognized that if shoppers were surrounded with appealing goods in eye-catching displays they would make spontaneous purchases; shopping became a delightful series of discoveries, motivated as much by newly sparked desire as by predetermined need. He also smoothed the path to purchase by fixing prices, eliminating the often contentious haggling between a customer keen to get a good price and a shopkeeper trying to drive up the sale. And Boucicaut's prices were good. Buying in bulk allowed him to undercut boutique prices, and he regularly offered sales, coordinated with the changing seasons as well as to introduce new products and fabric lines.

The Bon Marché was a great success (and still is), and Boucicaut expanded his premises until the emporium filled a full

Felix Vallotton (1865–1925)
Le Bon Marché, 1893, print
Private collection

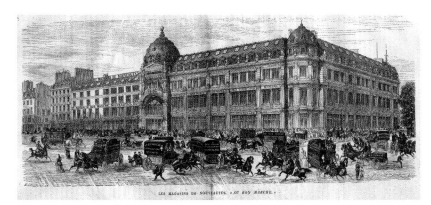

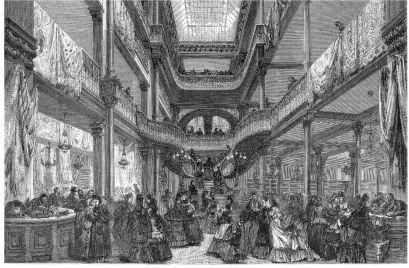

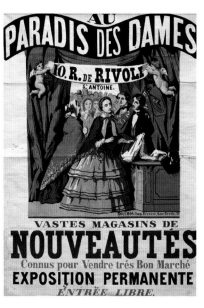

Left: *Exterior of the Bon Marché* (top) and
Interior of the Bon Marché, both 1872
Engravings

Above: Jean Alexis Rouchon (1794–1878)
Poster advertising the department store
Au Paradis des Dames, 1856
Colour lithograph
Bibliothèque Nationale, Paris

city block (above, top). The
interior featured wide-open
central halls that could host
fabulous displays of unfurled
fabrics, suspended umbrellas and
piles of shawls, carpets or bedding
(above). In Émile Zola's novel *Au
Bonheur des Dames* (1883), the *grand
magasin* is portrayed as a dazzling
cathedral of commerce in which
Octave Mouret, the owner of the
'Ladies' Delight', is as famous for

his artistic displays as he is for
his unlimited ambition. Zola
researched the novel by going on
shopping trips with his wife and
interviewing employees of the Bon
Marché. He described every aspect
of this new type of establishment:
the dormitories provided for the
female employees, the striving
clerks who worked on commission,
the breathtaking displays that
intoxicated the shoppers, and

the chaotic, surging crowd eager
to take best advantage of every
sale (opposite).

Boucicaut's *grand magasin*
inspired other retailers to open
similar shops, such as Les Galeries
du Louvre (1855), Printemps
(1865) and La Samaritaine
(1869). These giants forced the
boutique system into decline,
irrevocably changing commerce
on both sides of the counter.

In the Park

In the opening scene of Émile Zola's novel *La Curée* (1872), a wealthy woman and her adult stepson are caught in a traffic jam. As their driver jockeys for position, they while away the time in their snug, semi-enclosed barouche, commenting on the appearance and the attire of the passengers in nearby carriages. They pay little attention to their surroundings, but Zola describes the beautiful setting on a late October afternoon. Firs and evergreens cast a curtain-like shadow along the horizon; a lake gleams in the fading light. Groves of old trees open up into a rolling greensward, and, along the broad avenue, winding lanes and garden walks lead to other natural delights. But this 'scrap of nature' is 'like a newly painted piece of scenery', artificial and theatrical.[1] The pair are travelling through the Bois de Boulogne, the largest of the new city's parks, where every afternoon all of Paris gathers to witness 'the birth of the newest fashions'.[2]

Georges-Eugène Haussmann's plan of Paris allotted vast tracts of land to public recreation. Over the course of the Second Empire, royal holdings were converted to municipal land, increasing city parkland by nearly a hundredfold.[3] Some gardens, such as the Tuileries, remained under the monarchy's jurisdiction but offered expanded access to the public, as well as new amenities and entertainments. Others – most notably the Bois de Boulogne – were newly developed for popular activities, including watching horse racing, and horse riding, boating and skating. Broad lawns and gravel walkways encouraged strolling. Benches, well-manicured plantings and cooling fountains defined rest areas along the paths (see pages 88–89). Although some parks, such as the Bois de Boulogne, attracted a distinctly fashionable crowd, people from every level of society now had places in which to enjoy the fresh air and open space.

Swift train lines made it possible to have a picnic in the Fontainebleau forest, south of Paris (see pages 82–83), or to spend a Sunday on the Île de la Grande Jatte, to the city's west (pages 94–95), and

return home before the sun set. An air of informality
prevailed, prompting some men to trade their top
hats for bowlers and boaters; some even unbuttoned
their coats. Sportsmen's activities required special
apparel, but for women the riding habit was the
sole athletic costume. If a woman went walking,
boating or skating, she generally followed the
demands of fashion rather than of the sport (right;
see also pages 90–91). But whether in the centre
of the city or in the outlying suburbs, the sport of
people-watching reigned supreme, and, whether as
participant or spectator, everybody played.

Claude Monet
(1840–1926)
Le Déjeuner sur l'herbe
(The Picnic)

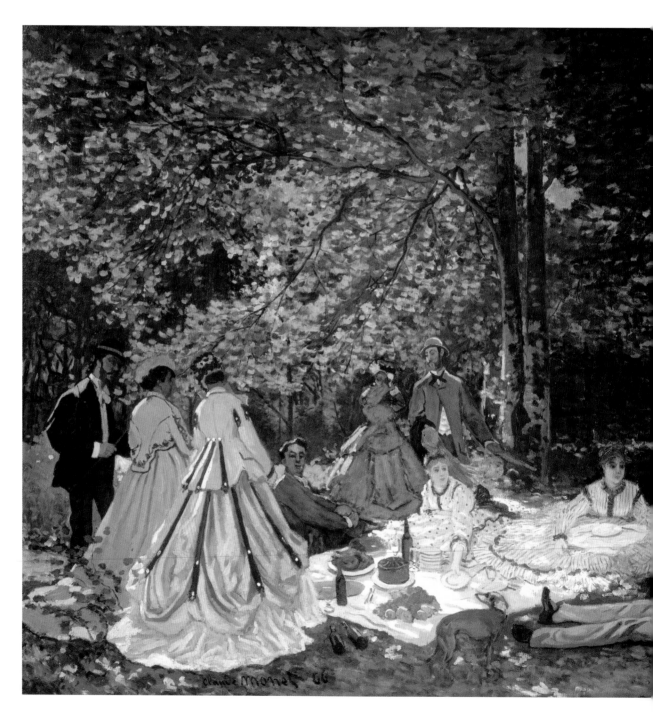

1865–66
Oil on canvas
130 × 181 cm
(51¼ × 71¼ in.)
The Pushkin State Museum
of Fine Arts, Moscow

Parisians seeking an afternoon's respite from the summer heat headed for the Fontainebleau forest near the village of Chailly-en-Bière, south of Paris. The forest had long been a royal domain, but part of it had been designated a public nature reserve in 1862, and a direct rail line, operating since 1849, made the 35-mile journey from the centre of Paris a popular day trip. In 1865 Claude Monet summered in Chailly in order to have daily access to this setting for *Le Déjeuner sur l'herbe*. Using his friends as models, he staged a picnic under the branches of a stand of old trees. The stylish garments and relaxed demeanours suggest the fleeting pleasures of an afternoon's escape; when the sun starts to wane the picnickers will pack their hampers, fold their blankets and return to Paris.

Monet rendered his subjects' attire with the same exacting eye that he used to record the dazzling effects of light. The men wear informal jackets and bowler hats; the lanky fellow lying on the ground in the right foreground – painter Frédéric Bazille (1841–1870) – lounges in shirtsleeves and an open waistcoat. The women's styles range from soft cotton dresses and a cartwheel hat to elegant walking ensembles. Both the detailed depictions and the women's poses recall popular fashion plates; Monet presents an accurate record of such up-to-date features as the yellow ensemble's postilion jacket, with a long tail at the back, and voluminous overskirt, drawn up with matching button-trimmed black bands. According to Émile Zola, Monet's fascination with 'men and women dressed in their finery' marked him as a 'true Parisian', who 'takes the city with him to the country'.[4]

Claude Monet
(1840–1926)

Women in the Garden

The white dresses that appear in Claude Monet's *Women in the Garden* were also depicted in his earlier painting, *Le Déjeuner sur l'herbe* (pages 82–83). Here he added a pale peach ensemble – worn by the woman holding the massive bouquet – featuring the *sacque* silhouette, a very full *paletot* jacket over a voluminous skirt, united by an uninterrupted line of buttons. Monet's keen attention to such details of fashion as the placement of buttons or braid prompted Émile Zola to declare that the painter 'loves our women', with 'their umbrellas, their gloves, their lace'.[5]

There is no doubt that Monet was attuned to the latest styles. The groupings of the women in both paintings mirror those in fashion illustrations, and his companion (and later, wife), Camille Doncieux, who modelled for both this work and *Déjeuner sur l'herbe*, was known to wear the latest attire. But Monet also recognized the fleeting nature of fashion; ever-changing, it represented the mutability of modern life and was as ephemeral as the effects of natural light.

In *Women in the Garden*, fabrics provide a surface for the play of light. The seated woman in the foreground wears white silk: a walking ensemble with a 'señorita' jacket over a wide skirt, banded with black and embellished with soutache trim.[6] Beneath her parasol the light is muted; the full range of illumination gleams on her skirt. The striped and dotted dresses were most likely made of tarlatan. Treated with a starched glaze, this light muslin maintains its shape as a garment in hot and humid conditions, but also reflects the most subtle sheen of light.

c. 1867
Oil on canvas
255 × 205 cm
(100⅓ × 80⅜ in.)
Musée d'Orsay, Paris

Auguste Renoir
(1841–1919)

The Swing

The sheath-like silhouette of the 1870s derived from Charles Frederick Worth's desire to shape a dress to the body without a seam at the waist. He began experimenting in 1863, and by 1874 he had perfected the princess line, named after Alexandra, Princess of Wales.[7] The dress was cut from lengths that ran unbroken from shoulder to hem, and that were tapered to fit the body with gores and darts. Within two years the flattering silhouette, sometimes called the 'long-limbed line', dominated all design trends, from morning gowns to evening wear. Wealthy women had their gowns custom-made and fitted to perfection, while those less privileged could find a pretty but affordable ready-made version at a department store.

The gown worn by the woman in Auguste Renoir's *The Swing* is cleverly designed to skim the body without needing to be custom-fitted. The white overdress has tapes inserted into the seams in order to allow the wearer to draw them up for a graceful, draped effect that adds volume without bulk. This also pulls the pleated flounce at the hem into a scallop that sets off the softer flounce of the deep-blue underskirt. The bows that run from the lace-trimmed neckline to the hem emphasize the unbroken line; this arrangement of bows or buttons was the favoured way to ornament the style. On the woman's left-hand side is a bit of bunched fabric, trimmed with a bow; this may be a pocket for a parasol, a necessary accessory for a stroll in the park on a summer's day.

1876
Oil on canvas
92 × 73 cm
(36¼ × 28¾ in.)
Musée d'Orsay, Paris

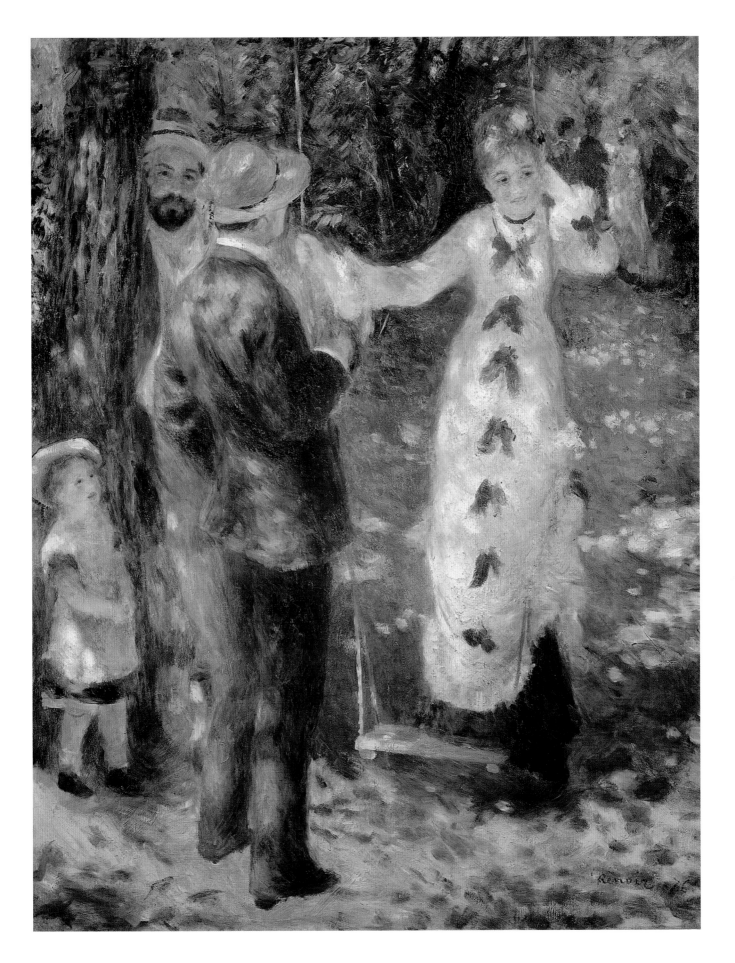

John Singer Sargent
(1856–1925)

In the Luxembourg Gardens

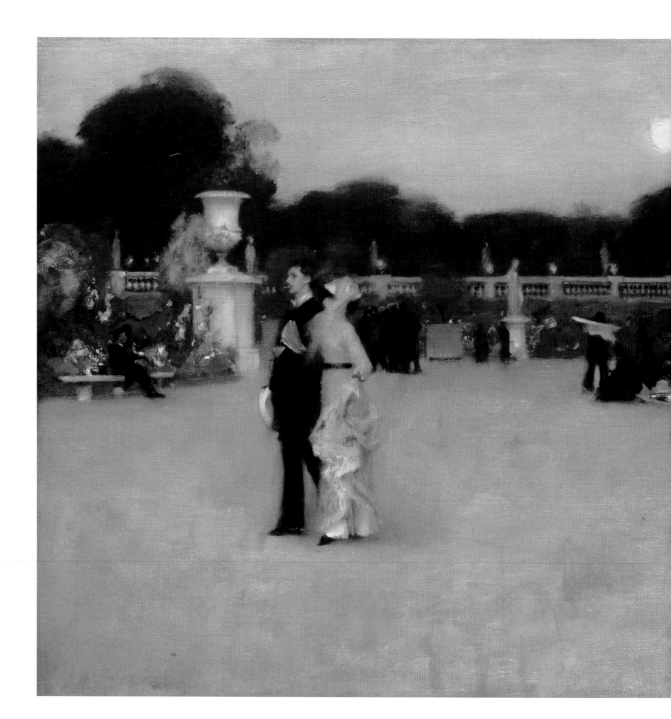

1879

Oil on canvas

65.7 × 92.4 cm

(25⅞ × 36⅜ in.)

Philadelphia Museum

of Art

John Singer Sargent portrays a fashionable couple strolling across the gravel parterre of the Luxembourg Gardens at twilight. On the right, other visitors to the park have gathered around the cooling waters of the oval basin: a dark-suited man can be seen standing and reading the newspaper, while his companion, also in black, sits near by with her back to the water; nursemaids, wearing distinctive round hats with aprons covering their dresses, look after the children in their care. On the other side of the open expanse, near a bank of vivid blossoms, a man relaxes on a bench and watches the world go by.

Once a royal garden, built in the seventeenth century for Marie de Medicis (by then the widow of Henri IV and regent for her young son, Louis XIII), the Luxembourg Gardens had been nationalized and opened to the public in 1791. Sargent strikes a perfect balance of the temporal and the timeless in his depiction of modern-day Parisians passing a summer's evening in a centuries-old park. As a setting, the garden retained the serene formality of the original plan, and it is easy to imagine earlier generations enjoying the tranquil atmosphere and the exquisite effect of evening's opalescent light.

But Sargent's graceful couple in the foreground embody a distinctive contemporary spirit that derives from more than just their stylish dress. The manner in which the woman lifts her fluttering, pale pink skirts and leans on her escort's arm, while he ambles with a boater in hand and smoking a cigarette, recalls Charles Baudelaire's insight about recognizing modernity: that 'every age had its own gait, glance and gesture'.[8]

Berthe Morisot
(1841–1895)

Young Woman Putting on Her Skates

1888
Oil on canvas
46 × 55 cm
(18⅛ × 21⅝ in.)
Private collection

Berthe Morisot and her husband, Eugène Manet (Édouard Manet's younger brother), made their home in Passy, located near the Bois de Boulogne.[9] Morisot had been raised in the affluent district, and, as did many other local residents, she regarded the vast park as an extension of her own garden. Napoleon III ceded the Bois, which was originally a royal hunting ground, to the city in 1852, and it was developed for public use. The plan created by Louis-Sulpice Varé and Adolphe Alphand featured broad boulevards, winding paths and several artificial lakes. Morisot's niece Paule Gobillard recalled that her aunt would rent a boat for her models while 'she, on the bank, painted'.[10] This lively oil sketch of a woman securing her ice skates reveals that the park offered pleasures in the winter as well as in the summer.

In order to lure city dwellers to the outskirts of Paris, the civic plan for the Bois included such special attractions as restaurants, cycling paths, boating lakes and a zoo. Skating was the main winter recreation, and the well-maintained rinks brought eager sportsmen, including the members of the exclusive Cercle des Patineurs skating club (founded in 1865). But women also skated. Wearing a regular street ensemble with a shortened skirt, a woman had only to strap blades to her sturdy winter boots to go out on the ice. The woman in Morisot's sketch makes a few concessions to the weather: she wears thick gloves and a voluminous scarf. But her jaunty hat leaves her ears exposed, and, with a deft stroke of rose-red, Morisot portrays the effects of the cold.

Mary Cassatt
(1844–1926)

Autumn

With a burnished palette of russet-brown, ochre-gold and forest-green, Mary Cassatt captures the experience of a chilly autumn day. Her sister Lydia sits alone on a park bench wearing a black bonnet, fawn-coloured gloves and a spectacular woven coat. There is no mistaking that she feels the bone-chilling cold. Her pale skin has a bluish cast, and she tucks her head down into the high neckline of her coat.[11] But the coat does more than serve as a warm garment; it also echoes both the colour harmonies of the surroundings and the season in vivid, more saturated hues.

This colourful coat is an exception to the dark colours that upper-middle-class women typically favoured for cold-weather garments. The bright tones, which seem all the more brilliant in striking combination, suggest that Lydia wears a *visite*, a winter mantle made from an imported shawl. Although these cashmere wraps had been very popular over the earlier decades of the nineteenth century, by the mid-1860s fashionable women had ceased wearing them for extra warmth over their coats.

In his novel *Pot-Bouille* (1883), which is set at that time, Émile Zola uses an outsize shawl as an emblem of ostentation; the pretentious Madame Josserand owned 'a sort of huge tapestry', which she wore on special occasions. She misinterpreted the gawking of passers-by as admiration, blithely unaware that the fashion 'for such things had long gone'.[12] More tasteful women would have had fine imported shawls converted into coats or wall hangings, or, if they were still wearing them for warmth, would have done so only in the privacy of their own homes.

1880
Oil on canvas
93 × 65 cm
(36⅝ × 25½ in.)
Musée du Petit Palais,
Paris

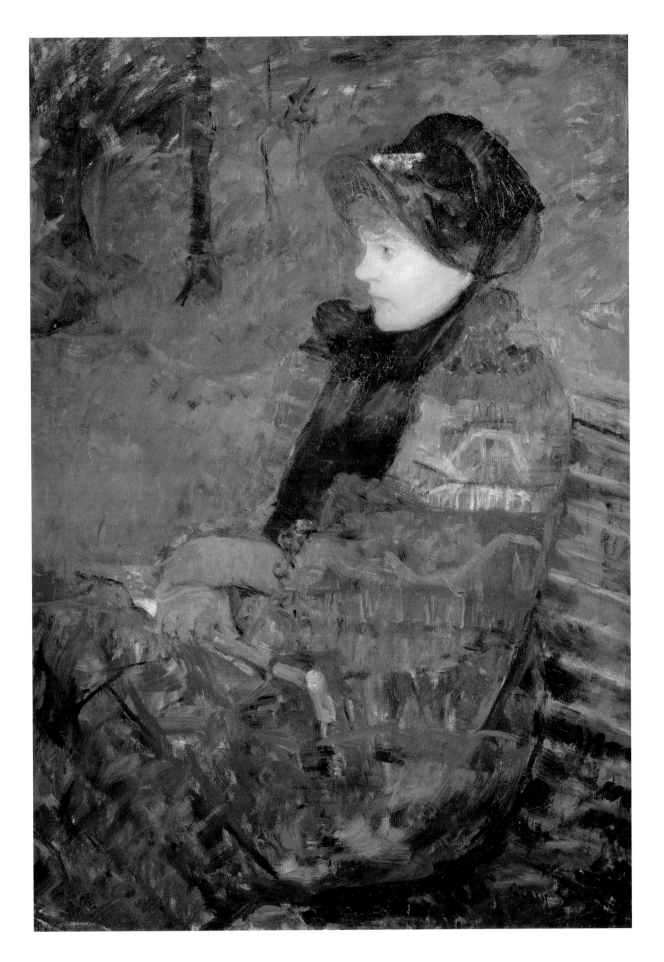

Georges Seurat
(1859–1891)

A Sunday on La Grande Jatte – 1884

The Île de la Grande Jatte in the River Seine, roughly 4 miles north-west of the city's centre, was a favourite summertime destination for Parisians seeking a leisurely spot in which to while away a Sunday afternoon. Georges Seurat regarded the island as the perfect setting for a panorama of modern life, and for nearly two years he made regular visits there to sketch the park on site. Over the months that he worked on the canvas in his studio, he made constant and subtle adjustments to the composition.[13] He also used his sketches to assemble a cast of characters – typical Parisians – using their costumes as a key to their identity.

Some of the distinctive modes of dress are related to professions (the soldiers in their blue jackets, or the nursemaid, sitting by a tree on the left, in her round hat with its trailing red ribbon), and there is boating garb (the *canotier* in his singlet, lounging in the left foreground), but for the most part the ensembles are conventional middle-class daywear. The only indications of concessions to the heat are the open parasols, the white dress of the little girl in the centre, and a man in the right-hand distance who has shed his jacket.

The couple in the right foreground embody the height of elegance. The man accessorizes his sharply tailored suit with a walking stick, a monocle and a rose boutonnière. The woman's striking dress features the *strapontin*, an extreme form of the bustle introduced in 1883 (see page 141). Keen to keep the details of his painting up to date, Seurat repainted the skirt after March 1885, enlarging and rounding out the bustle and raising the hemline off the ground.[14]

1884–86
Oil on canvas
207.5 × 308.1 cm
(81¾ × 121¼ in.)
The Art Institute of
Chicago

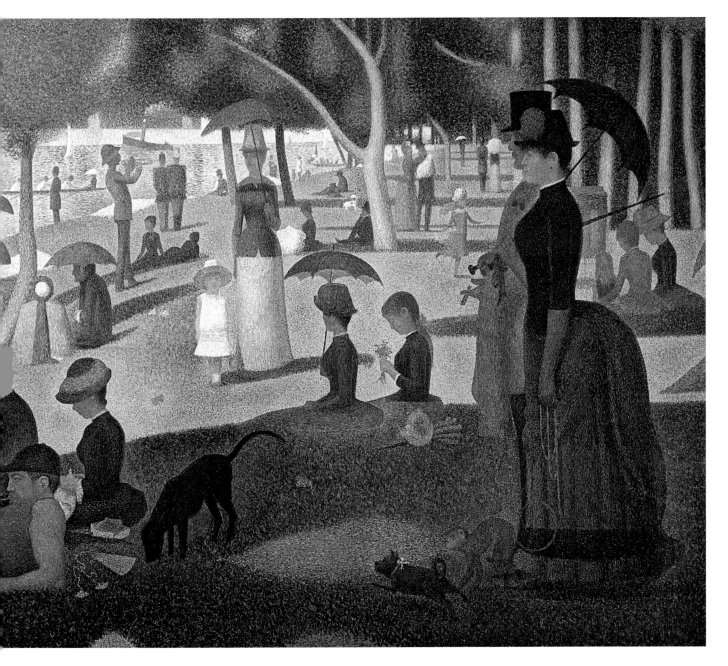

In the Park

INTERLUDE

At the Photographer's Studio

In 1854 photographer André-Adolphe-Eugène Disdéri (1819–1889) filed a patent for an inexpensive photographic format that he called the *carte de visite*. These small paper prints, mounted on cardboard, were roughly the size of a visiting card (about 10 × 6.5 cm/ 4 × 2½ in.), and to make them Disdéri used a camera of his own design, fitted with four lenses and a sliding plate holder (as seen in the example opposite). This allowed him to take four exposures, slide the plate to the opposite side and take four more, resulting in a total of eight images on a single glass plate. By capping individual lenses, Disdéri could offer his client up to eight separate poses. After developing the plate, he printed the images on sheets of paper – as many as the client requested – and snipped them apart and mounted them on supports. The rapidly made and affordable *carte de visite* portrait became one of the most popular keepsakes of the era. Other professional photographers adopted Disdéri's technique; within the decade it had become common practice for ordinary citizens to go to a studio and have these small portraits made to exchange with family and friends.

A well-equipped studio offered a selection of painted backdrops to simulate a natural or even an exotic setting, as well as such props as columns, chairs and even papier-mâché boulders. The photographer guided his sitters through the process, instructing them on how to pose, where to direct their gaze and how long to stay still. Some photographers employed head braces to keep the sitter from moving. For the most part, sitters wore their own clothes, and the ensemble of choice was formal daywear (rather than evening clothes) in order to convey their characteristic appearance.

Nadar (Félix Tournachon; 1820–1910)
Portrait of Édouard Manet, n.d.
Photograph, France

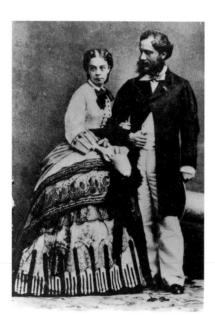

André-Adolphe-Eugène Disdéri (1819–1889)
Richard and Pauline von Metternich, 1860
Photograph, Germany

Lady with top hat, n.d.
Photograph, France

Men, as seen in the half-length portrait of Édouard Manet by Nadar (opposite, top right), presented themselves as confident and straightforward, facing the camera with an unflinching gaze. In the most popular couples' pose, the man looked lovingly at the woman, who held his arm, leaned against him and shyly glanced in the other direction. The couple featured here (opposite, left) was famous: Richard von Metternich was the Austrian ambassador to the French court; his wife, Pauline, was a close friend of the Empress, and, after Eugénie, the best-dressed woman in France. Women's poses often reprised the conventional postures of fashion plates, positioned in profile or at an angle that displayed and enhanced the graceful silhouette of their gowns.

In addition to having their own portraits taken, many people bought photographs of royalty and celebrities, as well as novelty images. In an era before fashion photography, these portraits served to circulate new or distinctive styles, as seen in the portrait of the lovely young equestrienne in her impeccable riding habit (opposite, bottom right).

Camera and photography, 1854
Münchner Stadtmuseum, Munich

Making the Scene

Day or night, there was always something to do in Paris. A morning stroll might culminate in an hour or two of leisure over a newspaper in a café. There were restaurants at all price points, so there was no need to return home for a midday meal. In the afternoon, options included concerts and matinees; pavement cafés and the park promenade offered another type of performance. And in the evening, the possibilities ranged from a glamorous night in an opera box to a nocturnal prowl along the notorious streets of Montmartre.

American writer Henry Tuckerman, dazzled by the array of activities undertaken by a citizen of Paris in a single day, claimed that these 'nomadic cosmopolites' required 'no domicile except a bedroom'.[1] But Tuckerman failed to add that sleep was not the only reason that a Parisian took a break from the city's pleasures; every venue required a specific ensemble, and to truly make the scene, a Parisian needed to put on the proper clothes.

Through appropriate attire, Parisians assumed their rightful place at every venue; conformity in dress displayed self-respect and social skill (see pages 100–101). Deviations from the dress code aroused suspicion or betrayed distressed circumstances. Even at a café, a man's slovenly appearance or the failure to remove his hat branded him as ill-bred or down on his luck (see page 108). At the opera, where married women exhibited their finest jewels as well as their arms and their shoulders, a young, unmarried woman was expected to highlight her innocence by choosing a more modest ensemble (see page 115). Grooming and the quality of attire proclaimed economic advantage, but a cleverly composed ensemble could blur the social hierarchy and disguise difference (see pages 102–103).

Both men and women acknowledged that public life required them to be on display and exposed to judgement, and they dressed with that in mind. But for women, the demands were greater than

Shoe Polisher, collector card
from *72 Dessins transparents
à voir à lumière*, No. 33
c. 1890
Colour lithograph
Chocolat Guérin-Boutron
Company
Private collection

they were for men. The cycle of a busy woman's day
necessitated as many as five or six changes, and she
had to navigate a narrow path between being admired
from a distance and drawing unwarranted attention
(see pages 112–13). Cheap clothes, loud colours and
garish ornaments were a signal that a woman wanted
to be approached, and that she would expect to
be paid for her favours (see pages 106–107). The
greatest challenge was for a respectable working
woman — a shop girl, a seamstress, a milliner — who
found herself exposed to public scrutiny; in that
circumstance, her garments and her demeanour were
her best protection (see pages 116–17).

Édouard Manet
(1832–1883)

Music in the Tuileries Garden

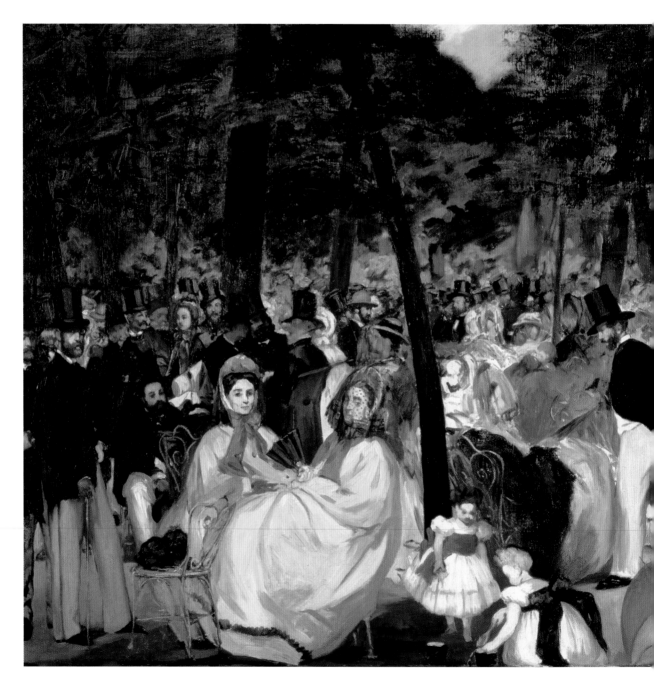

1862
Oil on canvas
76.2 × 118.1 cm
(30 × 46½ in.)
The National Gallery,
London

During the early 1860s Édouard Manet made daily excursions through Paris, sketchbook in hand, looking for subjects to paint. According to his friend Antonin Proust, he sketched in the Jardin des Tuileries almost every afternoon.[2] Parts of the royal garden had been open to the public since the eighteenth century, but under the new regime Parisians had unprecedented access to the grounds, and twice-weekly open-air concerts were staged for their pleasure. *Music in the Tuileries Garden* captures the milling energy of the crowd gathered beneath the chestnut trees for an entertaining afternoon.

Manet featured a number of portraits in his painting, including a self-portrait on the far left.[3]

But even without revealing their names, the individuals in this lively throng project an urban, middle-class sensibility; their clothes communicate their circumstances. The men all wear a variation of formal daywear: black jacket, grey or buff trousers, and a top hat, in hand if not on the head. The women's gowns are in an array of styles and in light summer colours, but every woman wears a bonnet or a hat. Even the children in the foreground, in their white dresses and bright sashes, are dressed according to prevailing conventions.

Charles Baudelaire, who can be seen in profile just behind the woman in the blue bonnet on the left, also recognized the distinctive urban behaviour of maintaining both individuality and anonymity in a crowd. He urged artists to regard the experience of the crowd as a revelation, for in 'the fugitive pleasure of circumstance' they would discover the essential quality of modernity.[4]

Auguste Renoir
(1841–1919)

Bal du Moulin de la Galette
(Dance at the Moulin de la Galette)

In the nineteenth century, a pair of old windmills near the crest of the Butte Montmartre, to the north of the city, marked a popular destination for drinking and dancing. The site was known as the Moulin de la Galette, after the buckwheat pancakes associated with the larger mill.[5] Throughout the year, pleasure seekers enjoyed refreshments in a café at the base of the larger mill and dancing in a nearby shelter. But by the 1860s the favourite amusement was the dance held there every Sunday in summer, from mid-afternoon until midnight, in an enclosed courtyard surrounded by acacia trees.

Auguste Renoir enjoyed this weekly event, and he conveys the distinctive spirit of casual conviviality in his depiction of the sunlit courtyard filled with eye-catching young dancers. Few places in Paris attracted a more diverse crowd. Mingling with the local residents – artisans and factory workers – were artists and left-wing intellectuals, as well as shop girls, milliners and seamstresses, all drawn to the inexpensive entertainment. Renoir sketched the scene on site, but he composed the work in the studio, hiring models to pose as the flirtatious women and recruiting his friends to play their easy-going male companions.[6]

Many of the men sport boaters rather than top hats; this is a sign of the relaxed atmosphere. The women are stylishly dressed, in lightweight, lace-trimmed gowns with pleated cuffs. Critic Georges Rivière, who posed for the painting, hinted that the women made their own Sunday dance ensembles in imitation of current trends and were 'proud of their costumes whose cloth cost so little and whose sewing, nothing.'[7]

1876
Oil on canvas
131 × 175 cm
(51⅝ × 68⅞ in.)
Musée d'Orsay, Paris

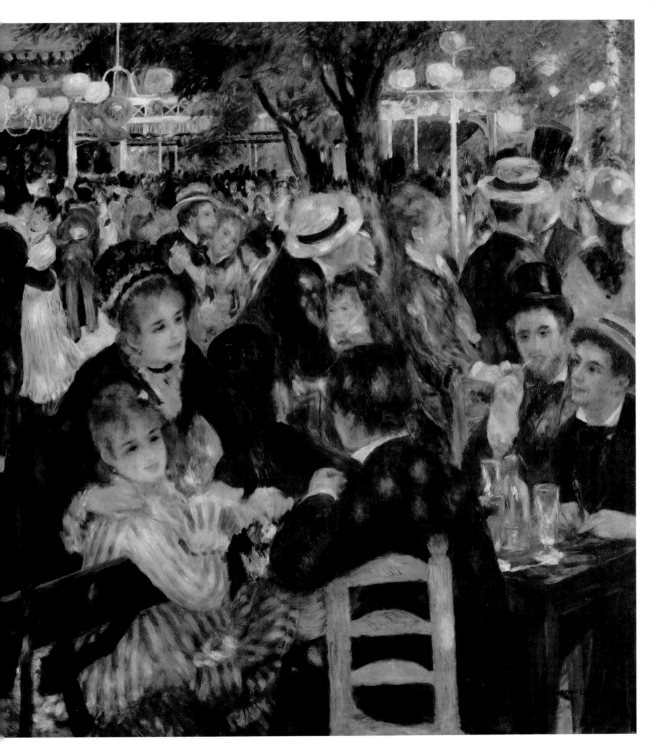

Edgar Degas
(1834–1917)

The False Start

c. 1869–72
Oil on panel
32.1 × 40.3 cm
(12⅝ × 15⅞ in.)
Yale University Art
Gallery, New Haven,
Connecticut

Popular interest in horse racing rose in France throughout the nineteenth century, but in 1857, when the new racecourse at Longchamp opened as part of the development of the Bois de Boulogne, the sport came to play a role in the annual cycle of fashion. The April race week not only opened the sporting season, but also was the debut event for new springtime fashions. Wealthy aficionados arrived in open carriages; less stylish patrons would crowd the stands and sidelines to admire their attire. Those who did not attend lined the pavements of the Champs-Élysées to get a glimpse of the elegant procession into the park.

Edgar Degas's own interest in horses and racing began in 1861, prompted by a visit to Ménil-Hubert, an estate in Normandy recently acquired by the family of his friend Paul Valpinçon.[8] His sketches of the subject date from this time – the family allowed steeplechases on their property – and his interest endured throughout his career.

Degas's racing pictures, such as *The False Start*, capture the sense of the spectacle but concentrate on the milling crowds, the building excitement, the jockeys' colourful silks and the restless horses, rather than the race itself. The stands depicted here differ from those at Longchamp, and the location has yet to be identified. In this work, the crowd also remains anonymous. There are as many women in the crowd as men; their white parasols, light dresses and bright bonnet ribbons stand out among the grey and black of the male attire.

Edgar Degas
(1834–1917)

Women on a Café Terrace, Evening

1877
Pastel over monotype
41 × 60 cm
(16⅛ × 23⅝ in.)
Musée d'Orsay, Paris

Walking through Paris on a summer's night in 1876, American writer Henry James pondered the sheer number of people out on the streets. And, unlike in New York, where a stroller had to sit on a '"stoop" or a curbstone' to rest and enjoy the cool evening air, the boulevards of Paris provided the novelty of 'a long chain of cafés, each with its little promontory of chairs and tables projecting into the sea of asphalt.'9 In mild weather, throughout the city café proprietors took advantage of the capacious new pavements flanking the broad avenues. The pavement café offered respite and refreshment for a weary pedestrian, as well as a comfortable place for a *flâneur* (stroller) to pass an evening. What James did not reveal was that in some districts the street-side café facilitated encounters between men of acceptable society and women of the demi-monde.

The women in Edgar Degas's pastel wear cheap, garish garments. They look showy rather than stylish in their brassy accessories and crudely ornamented hats. Across the street, shadowy figures pass under the glare of gaslight, and the brightly lit windows behind them suggest a location on the boulevard Montmartre. The women are comfortably seated, on a break from their own nocturnal rambles, relaxing over a drink and conversation. Critic Georges Rivière speculated that these *demi-mondaines* were discussing their clients; the woman in the centre flicks her thumb off her teeth as if to say 'Not even that', while her companion slaps the table with her 'large gloved hand' in agreement.10

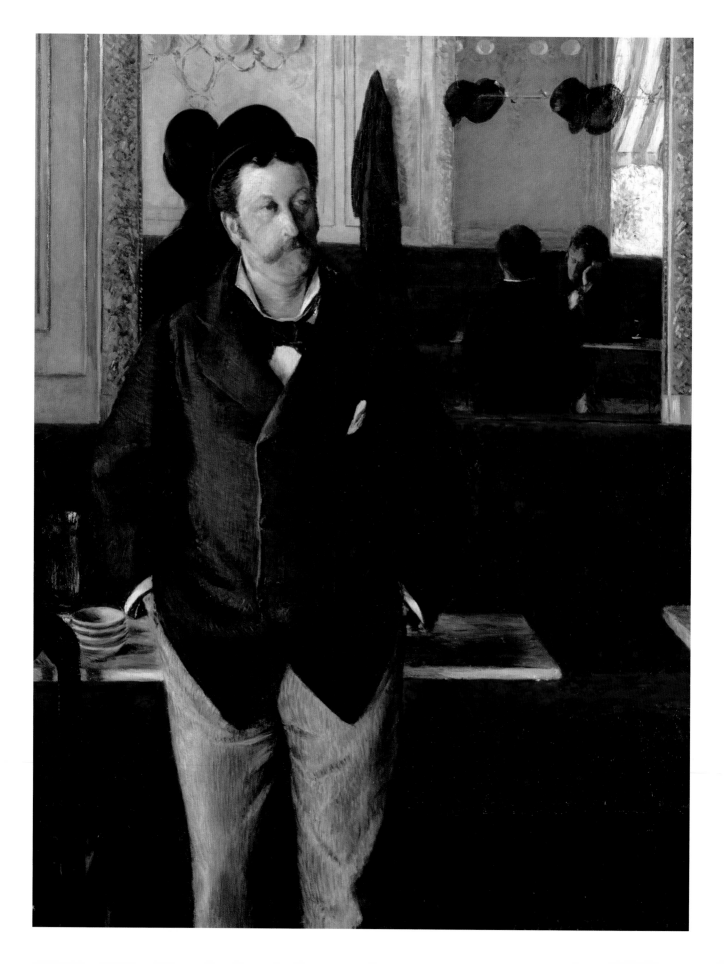

Gustave Caillebotte

(1848–1894)

In a Café

American journalist Edward King described the Parisian café as the city's main stage, where men gathered to gossip and intrigue. A visitor looking for authentic Parisian life would find it there, for, according to King, the city 'plots, it dreams, it suffers, it hopes, at the café'.[11] The café did play a central role in urban life. It was a public space that provided the setting for domestic activities: eating and drinking, chatting with friends, or finding a comfortable place in which to pass the time in solitude. But, unlike the home, the café was primarily a male domain, as seen in Gustave Caillebotte's depiction of an unnamed café and its anonymous habitués.

Caillebotte poses his main figure leaning back on a marble tabletop. The gilded mirror above the red upholstered banquette allows the viewer to share in his languorous gaze as he surveys the room. Sunlight streams in from the window on the opposite wall; outside, a striped awning can be seen, suggesting that there are tables on the pavement. The two men sharing the table near the window seem to be lost in their own thoughts. They have hung their top hats on the wall above, but the fellow standing has not removed his hat; it is a softer version of the American derby known as a 'melon'. In contrast to the better-dressed patrons seen in the mirror, his loose tie and wrinkled trousers seem to indicate that he is down on his luck and has nothing better to do but stand there and take in the scene.

1880
Oil on canvas
153 × 114 cm
(60¼ × 44⅞ in.)
Musée des Beaux-Arts,
Rouen

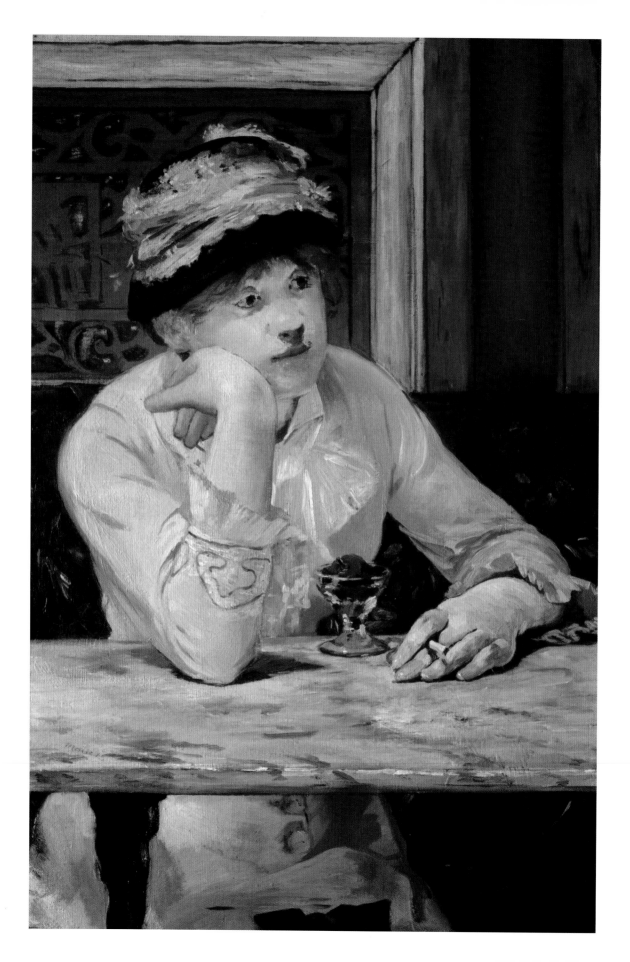

Édouard Manet
(1832–1883)

Plum Brandy

c. 1877
Oil on canvas
73.6 × 50.2 cm
(29 × 19¾ in.)
National Gallery of Art,
Washington, D.C.

In his 1860 study of women in France, the historian Jules Michelet cautioned that a woman risked her reputation if she entered a café on her own: 'All eyes would be fixed on her and she would overhear uncomplimentary and bold conjectures.'[12] But in the years that followed, as more women entered the workplace as shop girls, seamstresses and milliners, women increased their social independence by earning a wage, living on their own, and enjoying the relaxed atmosphere and refreshments served in public establishments.

There has been much speculation about the character of the woman that Édouard Manet portrayed in *Plum Brandy*. He depicts her seated alone at a café table. The decorative grille behind her suggests that the location was the Nouvelle Athènes in place Pigalle; Manet frequented that café throughout the 1870s. But rather than showing her scanning the room for a companion, Manet presents her absorbed in her own thoughts, dawdling over an unlit cigarette and a brandy-soaked plum.

Her garments offer a persuasive case for a respectable identity. By this time, a shop girl could afford an inexpensive version of the latest ensemble, and the long, cuirass bodice of her pale pink suit is absolutely up to date. Her accessories – loosely tied fichu and modestly trimmed hat – seem chosen for flair rather than for flash. In his novel *Au Bonheur des Dames* (1883), Émile Zola noted that the women who worked in the finer shops dressed in the same manner as their middle-class clients, and, as a result, they occupied 'an indistinct social class' caught 'between the workers and the bourgeoisie'.[13]

Édouard Manet
(1832–1883)

The Garden of Père Lathuille

1879
Oil on canvas
92 × 112 cm
(36¼ × 44⅛ in.)
Musée des Beaux-Arts,
Tournai

Édouard Manet's painting portrays Louis Gauthier-Lathuille, whose father ran a restaurant in the Batignolles district, in the north-western fringes of central Paris. Manet knew both the establishment – it was located next door to Café Guerbois, where he regularly met his friends – and the proprietor. During the summer of 1879 Gauthier-Lathuille was home on leave from military service, and Manet admired the way he looked in his uniform. The painter conceived this narrative vignette, set on the restaurant's garden terrace, to capture the dashing appearance of the young soldier, and hired the actress Ellen Andrée to pose with him. But after a few sittings she failed to show up, and Manet replaced her with Judith French, a cousin of the composer Jacques Offenbach.[14] When the new model took her place at the table, Manet suddenly demanded that Gauthier-Lathuille replace his uniform with the artist's own smock.[15]

Manet painted *The Garden of Père Lathuille* on site, and his models' garments, as much as their gestures, put a humorous spin on modern-day seduction. The woman's bourgeois reserve is emphasized by her meticulous appearance in her brown summer dress, fingerless lace gloves and pertly placed hat on neatly coiffed hair. The handsome young man, in a buff-coloured smock and carelessly knotted tie, plays a bohemian lothario. He has approached the woman as she begins to eat her fruit course; kneeling beside her, he drapes one hand on the back of her chair and cradles her wine glass with the other, but she meets his soulful glance with rigid posture and pursed lips. Manet completes the scene with a waiter in the background, who, along with the viewer, watches events unfold.

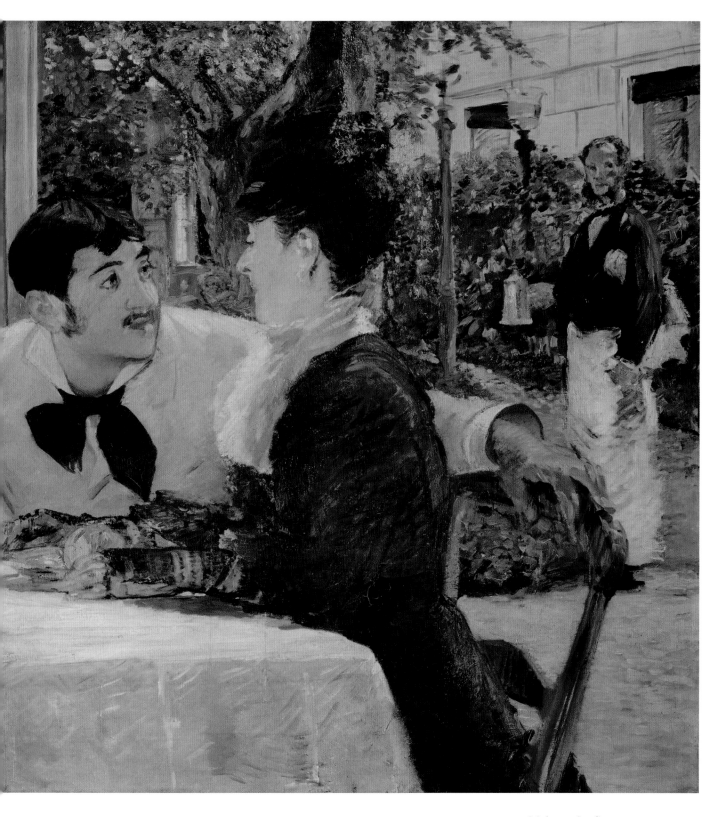

Mary Cassatt
(1844–1926)
The Loge

Patrons of the opera were well aware that when attending a performance they were as likely to be observed as were the artists on the stage. The two young women portrayed by Mary Cassatt in a mirrored loge seem very conscious of this scrutiny. Mary Ellison, a visiting American, and the daughter of the poet Stéphane Mallarmé, Geneviève, convey the apprehensive excitement of the moment. In their delicate tulle gowns and unadorned elbow-length gloves, they draw close to one another. Geneviève sits perfectly still, while Mary hides behind a painted fan. Their youth, as well as their self-consciousness, suggest that this is their debut; wary but ready, they submit to admiring glances.

For the opera, a woman indulged in her most extravagant display, as if groomed and gowned for a ball.[16] Married women often wore colourful gowns and the most dazzling *parure* their husbands could afford. But young, single women had to project a more demure demeanour. Pale, layered fabrics – as seen here, with just a breath of pink or blue – were worn to highlight a youthful complexion. Although the gown worn by Geneviève reveals her smooth shoulders, the plain corsage with its straight-cut, unembellished neckline neither exposes nor accentuates her breasts. And neither Mary nor Geneviève wears gemstone jewellery; it would have been unseemly for women of their age to enhance themselves with more than a thin black ribbon or a modest string of pearls. With their simply dressed hair (perhaps worn up for the first time) they project the aura of innocence associated with a respectable feminine ideal.

1882
Oil on canvas
79.8 × 63.8 cm
(31⅜ × 25⅛ in.)
National Gallery of Art,
Washington, D.C.

Édouard Manet
(1832–1883)
A Bar at the Folies-Bergère

The extravagant nightly entertainments offered at the Folies-Bergère attracted the most diverse crowds in Paris. In his novel *Bel-Ami* (1885), Guy de Maupassant lists male habitués from every sector of society: shop clerks, bureaucrats, 'officers in mufti' and 'would-be dandies in evening dress'. He sees less variety among the female patrons, who share the singular pursuit of finding wealthy men who will pay for their evening.[17] But there were other types of working women at the Folies-Bergère, and Édouard Manet captures the ephemeral spirit of Parisian nightlife in such an iconic figure at the centre of *A Bar at the Folies-Bergère*.

The barmaid stands ready at her post: one of the marble-topped, mirror-backed bars that lined the promenade gallery above the open dance floor. As a *serveuse*, she mixes drinks, and, unlike the waitresses who circulate among the patrons, she works from behind the barrier of her bar. Her close-fitting buttoned bodice, with its deep, lace-trimmed décolletage, has a military air; it is the house uniform that identifies her role and rank within the establishment.

No one in the bar would confuse the *serveuse* with its more glamorous patrons, but her uniform echoes the style lines of fashionable apparel. As she was a representative of the Folies-Bergère, it was crucial that she be well groomed and attractively attired. Beautiful and fashionable – and described at the time by critic Paul Alexis as 'truly alive, truly modern' – she also seems removed from her surroundings.[18] Manet's depiction of the silent, statuesque barmaid is more an icon than a portrait, and personifies a timeless ideal of womanhood in contemporary dress.

1881–82
Oil on canvas
94 × 129.5 cm
(37 × 51 in.)
The Courtauld Gallery,
London

INTERLUDE
At the Milliner's

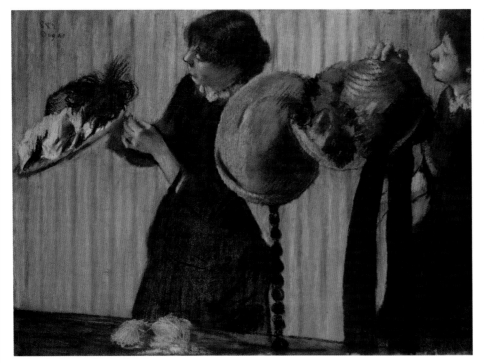

Edgar Degas (1834–1917)
Little Milliners, 1882
Pastel on paper
48.9 × 71.7 cm (19¼ × 28¼ in.)
Nelson-Atkins Museum of Art,
Kansas City, Missouri

Although women often updated hats themselves with new ribbons or fresh veiling, for a new one a woman headed to her milliner.

The millinery shop was an exclusively female domain, run by women, staffed by women and catering to a female clientele. Men purchased their hats at separate establishments; hat-making and millinery were distinct trades. Most milliners' shops, from the modest to the grand, stocked blank hats, made off the premises, which were then fitted and trimmed for individual clients.

The proprietress, always addressed as Madame, served as the creative director; her

When outside of her home, a woman always wore a hat, although the style varied according to season, function and the ever-changing dictates of fashion. A hat provided the finishing touch to a woman's ensemble, and once she had put it on she did not take it off again until she returned to her own residence – in contrast to men, who removed theirs frequently as a sign of respect. In terms of style, hats were the most variable element in a woman's wardrobe. Even women of moderate means had several, and generally a new hat cost a good deal less than a new ensemble.

French School, *The Milliner, from a series of different trades*, 1899, colour lithograph
Bibliothèque des Arts Décoratifs, Paris

Felix Vallotton (1865–1925)
La Modiste (The Milliner), 1894
Woodcut in black on ivory wove paper
25.1 × 32.8 cm (9⅞ × 12⅞ in.)
The Art Institute of Chicago

taste, and her ability to attract a clientele of important people, set the standard for the shop. But in grand shops all but the most elite clients consulted with an *essayeuse* (fitting assistant) rather than Madame. The *essayeuse* would guide the client through the selection process, advising her on matters of style and fit. Finished hats on stands displayed the latest trends and trimmings, but each customer's hat was trimmed to order by a *garnisseuse* (trimmer), who usually worked in the back of the shop. She followed the instructions of the *essayeuse*, but was permitted artistic licence based on her skill and taste, especially in choosing individual ornaments from a stock of ribbons, feathers and artificial flowers.

When the hat was finished, the customer returned for a final fitting and to approve the embellishments. Once again, she would be served by the *essayeuse*, but in many shops the *garnisseuse* stood by to make minor adjustments. If a woman was displeased with the *garnisseuse*'s embellishments, the hat would be reworked until she was satisfied. Typically, both the *essayeuse* and the *garnisseuse* dressed in simple, well-cut dark gowns that set a tone of respectability for the shop and immediately differentiated them from their clientele. A savvy milliner realized that pleasing her customer required more than just providing a pretty hat. No item of clothing was more personalized, and the indulgent attention given to the customer through every stage of the process guaranteed that a woman left the shop with not only a new hat but also an enhanced sense of confidence.

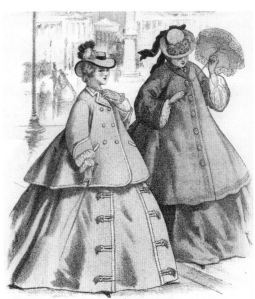

French Ladies' Fashion, 1861
Lithograph, Germany

Making the Scene 119

On Holiday

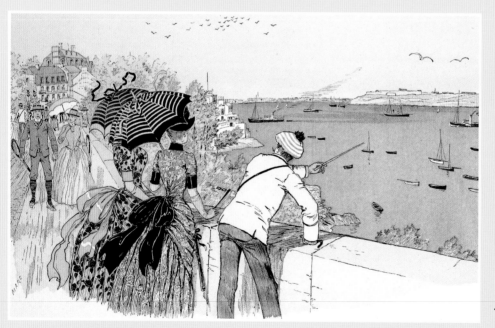

As the Paris correspondent for the *New York Tribune*, Henry James informed his readers of a phenomenal fact. In contrast to the unrelenting round of social and cultural events that had crowded his schedule since last December, now, in late July, he found that 'there is little to do or see, and therefore little to write about.' For many city dwellers, high summer marked the time for a holiday, and James acknowledged that there was only one thing a visitor could do: emulate the Parisians and 'get out of Paris'.[1] Although the city had been much improved by urban regeneration, the heat of summer could become oppressive. People of all walks of life sought a respite, however brief, from the crowds, the confinement

After Maurice Bonvoisin
(Mars) (1849–1912)
The Bay of Dinard
1888
Colour lithograph
From *Plages de Bretagne et
de Jersey* (1888)

and the hectic pace. Affluent families retreated to homes in the country or to seaside resorts, but even a working man or woman, with a little money and time to spare, could escape the city's swelter for at least an afternoon.

The expansion of the railway system gave Parisians an unprecedented range of destinations. The city's wealthiest residents – including the imperial circle – headed to the Normandy coast to enjoy the charm of such villages as Trouville (see page 125). Those less advantaged went to such riverside suburbs as Chatou or the Île de Croissy for water sports or to relax on the shady terrace of a popular café (see page 139).

As was the case with manners, dress reflected the more relaxed atmosphere. Women wore lighter fabrics, brighter colours and straw hats. Men traded their dark attire for pale suits in loosely woven fabrics, often adopting elements from sportswear (see page 122). Serious male athletes dressed for their sport; their female friends wore styles that expressed

their support. Even a brief day out in the country inspired a more playful air. For a day trip to Joinville, Denise Baudu, the shop-girl heroine of Émile Zola's *Au Bonheur des Dames* (1883), did her best to freshen up her old woollen dress with a trim of blue-and-white poplin.[2]

These holiday destinations played a special role in the Impressionist repertoire. Such members of the circle as Édouard Manet and Gustave Caillebotte enjoyed the luxury of family homes, where they could relax as well as paint (see pages 133 and 135). Others, including Claude Monet and Auguste Renoir, frequented popular boating and bathing sites, combining their work with pleasure (see pages 126–27). But, as the crowd gathered round the table in Renoir's *Luncheon of the Boating Party* (pages 136–37) reveals, even on a holiday, there was always the presence of genuine Parisian style.

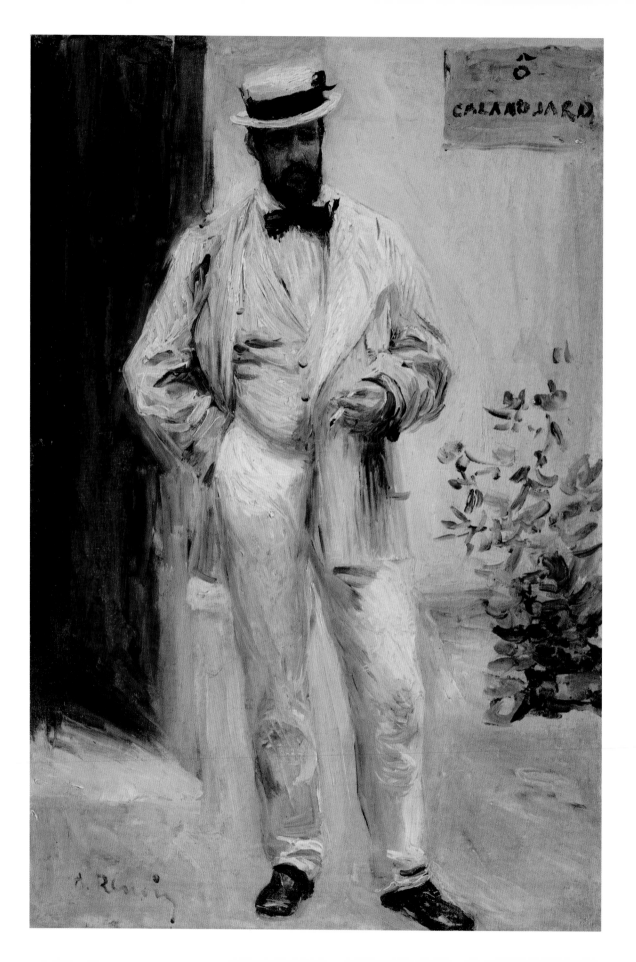

Auguste Renoir
(1841–1919)

Portrait of Charles Le Coeur

1874
Oil on canvas
42.8 × 29.2 cm
(16⅞ × 11½ in.)
Musée d'Orsay, Paris

On a summer holiday, men traded their sombre dark ensembles for suits of lightweight flannel or linen in such pale shades as white, buff or cream. As seen in Auguste Renoir's portrait of architect Charles Le Coeur, the elements of men's informal daywear remained the same – a sack coat and matching waistcoat, paired with contrasting stovepipe trousers – but small details, such as the loose bow tie, as well as the light fabric and pale tones, gave holiday wardrobes a jaunty air. The pinstripe pattern of the jacket was adopted from boating suits worn by wealthy sportsmen. The flat-crowned, narrow-brimmed hat with its decorative band (known as the boater) also had nautical origins; a fashionable man would never wear a boater in an urban setting, no matter the colour of his jacket.

Le Coeur posed for Renoir in Fontenay-aux-Roses, a village south-west of Paris in which Le Coeur and his family had recently purchased a holiday retreat. His carefree posture – one hand in his pocket and the other holding a cigarette – expresses the pleasure of escaping strict urban decorum. In the upper right-hand corner, Renoir added a bit of wordplay, inscribing *Ô Galand Jard* as shorthand for Au Galant Jardinier, the name of a local inn.[3] Perhaps he meant the phrase as a good-natured jab at his immaculately tailored friend. Although the sack coat had the loose cut of a worker's jacket, the fitted waistcoat and white flannel trousers were intended for a man of leisure, not labour.

Eugène Boudin
(1824–1898)

Princess Pauline Metternich on the Beach

Marine painter Eugène Boudin captured a glimpse of fashion that was as fresh as the atmosphere of his beachside locations. He worked along the Normandy coast in such resort towns as Trouville and Deauville, where elegant Parisians, including the Empress, spent restorative holidays at the shore. Boudin concentrated on the volatile light effects that he observed while working *au plein air*, but he also turned his keen eye to the details of vacationers' stylish apparel. In this painting, he represents one of the boldest trend-setters of the imperial circle: Princess Pauline von Metternich, wife of the Austrian ambassador to the French court and friend of Empress Eugénie.

Princess Pauline jokingly referred to herself as *le singe à la mode* ('the fashionable monkey').[4] Her looks may have been plain, but her wardrobe was spectacular. She was one of Charles Frederick Worth's first clients; she is often credited with introducing the couturier to the Empress, and throughout the Second Empire she remained loyal to him. He appreciated her daring, and it was often Princess Pauline who debuted new style lines or accessories designed by Worth (see also pages 56–57).

Even the Princess's casual seaside attire features Worth's newest innovations. She wears a small, smart straw hat, perched forward and secured with a trailing ribbon so as not to spoil – or hide – her coiffure. Her white dress and tunic jacket have black applied embellishments that delineate the style lines at the shoulder, cuff and hem. The skirt is drawn up to keep it off the damp sand, revealing a splendid scarlet petticoat that adds eye-catching dash to a simple ensemble.

c. 1865–67
Oil on cardboard laid down on wood
29.5 × 23.5 cm
(11⅝ × 9¼ in.)
The Metropolitan
Museum of Art, New York

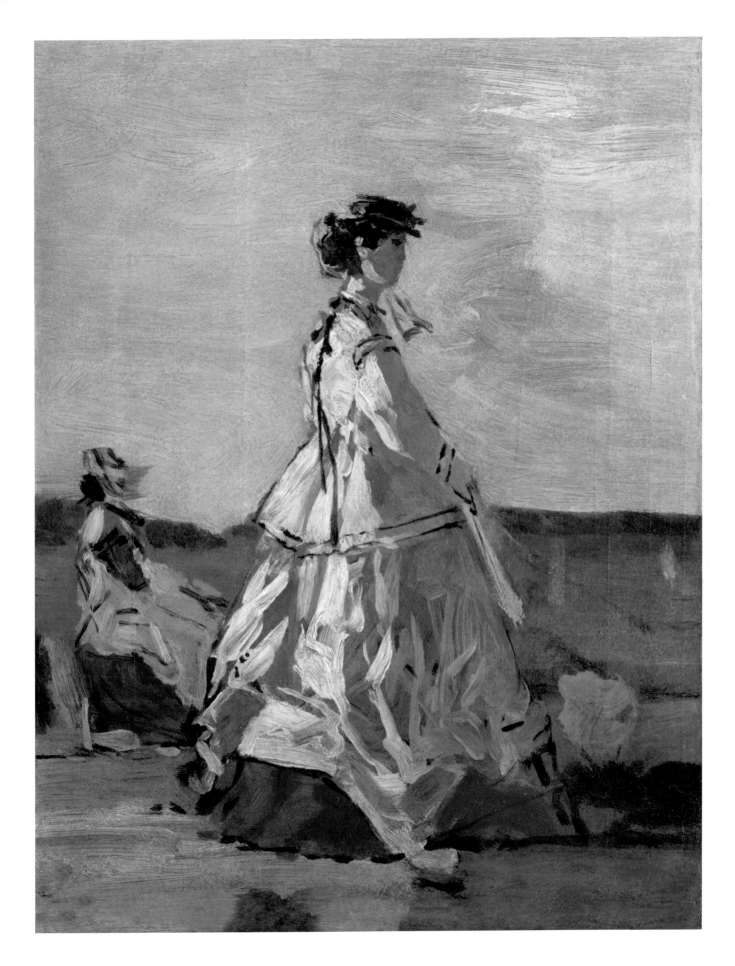

Auguste Renoir
(1841–1919)

La Grenouillère

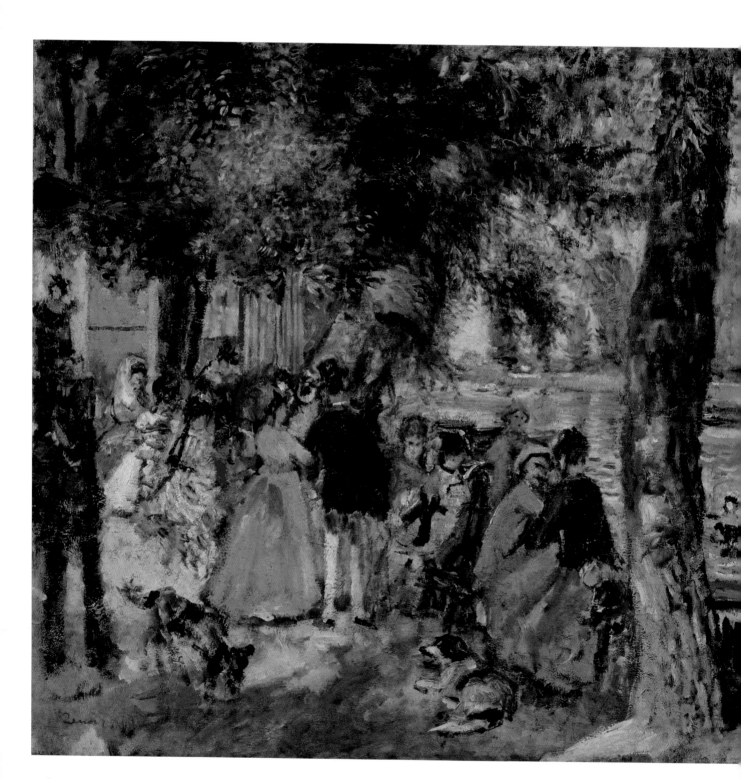

1869
Oil on canvas
59 × 80 cm
(23¼ × 31½ in.)
The Pushkin State
Museum of Fine Arts,
Moscow

Not all Parisians could afford to travel to a coastal resort for a seaside holiday, but the rise of the rail system presented an alternative: a day of boating, bathing and socializing at such riverside sites as La Grenouillère on the Île de Croissy on the River Seine near Bougival, west of Paris. Run by a man named Seurin, La Grenouillère combined the relaxed atmosphere of a café with popular water sports. Customers could drink, dine and dance on two moored barges and an artificial island, and, for a small fee, they could rent boats, bathing suits and changing huts. Seurin even offered lessons in swimming and rowing. The playfully named establishment (*la grenouillère* means 'frog pond') drew a young

and diverse crowd, and, by the summer of 1869, when Auguste Renoir and Claude Monet went there together to paint, it was a favourite destination for a day trip, touted as 'Trouville on the banks of the Seine'.[5]

Renoir painted several scenes at La Grenouillère, and in this view he focuses on patrons in summer street clothes on the river bank, milling around under shady trees. The narrow footbridge on the right connects the bank with the artificial island. Just beyond, bathers bob in the water. Seurin permitted mixed bathing, setting rules about costume: men were required to cover their bodies from the chest to the knees. But the rules were not strictly enforced at La Grenouillère; a bare-chested man can be seen between the two women in their simple – and identical – rented suits. This air of informality, perfectly conveyed through Renoir's supple brushstrokes and shimmering palette, was key to the establishment's appeal.

Edgar Degas
(1834–1917)

Beach Scene

Prior to the middle of the nineteenth century, swimming was a segregated activity, pursued mostly by men, who commonly swam in the nude. By the 1850s, seaside holidays were bringing mixed bathing, and more attention was given to appropriate costume. Men donned a more substantial version of their undergarments, covering their chest, torso and thighs. Women's costume had a similar silhouette, with a higher neck and longer legs and sleeves, supplemented by an overskirt and dark stockings. For modesty, the fabrics used were dense, such as wool flannel, serge and rep (with a ribbed surface); when wet, they did not cling. Dark colours were favoured in order to further reduce exposure, and they were brightened up with nautical trim in white and red.

Edgar Degas's *Beach Scene* depicts a girl with her nursemaid, relaxing after a swim. Her brown suit and matching cap are spread out on the sand to dry, while the nursemaid, in a crisp, long-sleeved white blouse and an apron over her skirt, combs the tangles out of the girl's damp hair. Strollers in informal daywear walk along the shore, while to the left another nursemaid leads her charges out of the water. The tallest child wears a cap and stockings, identifying her as a girl; the bare legs of the smaller two reveal that they are boys. The smallest of them turns to look at the languid girl, a detail that suggests on-the-spot observation. But in fact Degas painted the scene in his studio, and his model reclined on the floor with her head on his flannel vest.

c. 1869–70
Oil on paper on canvas
47.5 × 82.9 cm
(18⅝ × 32⅝ in.)
The National Gallery,
London

On Holiday 129

Édouard Manet
(1832–1883)

The Croquet Party

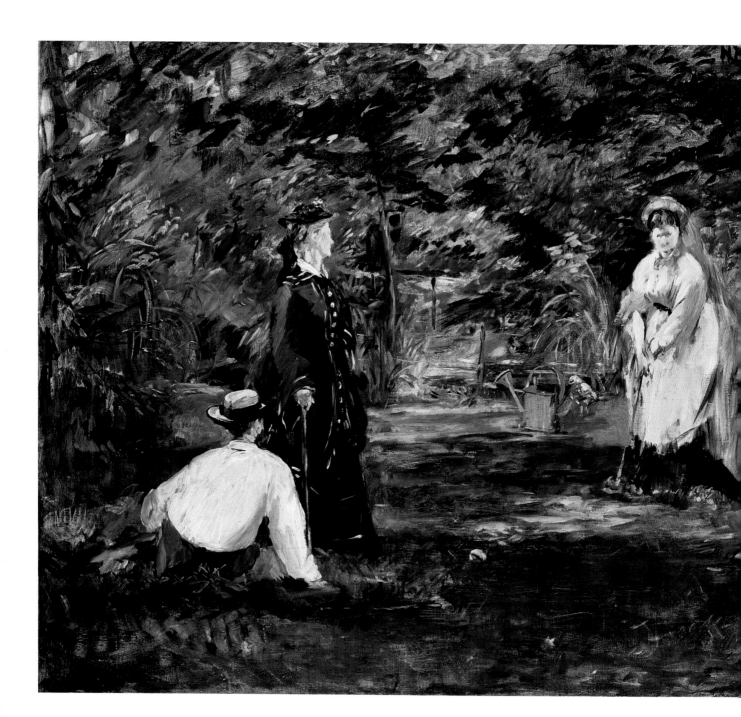

1880–81
Oil on canvas
129.5 × 172.7 cm
(50⅞ × 68 in.)
The Phillips Collection,
Washington, D.C.

Auguste Renoir
(1841–1919)
Luncheon of the Boating Party

The picturesque village of Chatou, less than 9 miles by train west of the centre of Paris, was a popular spot for boating and bathing along the Seine. Riverside restaurants featured broad terraces and substantial midday meals to cater for the summer Sunday crowds. Auguste Renoir favoured La Maison Fournaise, and his depiction of the *Luncheon of the Boating Party* conveys the pure pleasure of sharing good food with good company on a sunny afternoon.

La Maison Fournaise attracted competitive rowers (*canotiers*), and the bare-armed men in white singlets are dressed for the sport. Note that the *canotier* on the left wears a straw hat with a soft silhouette; he is Alphonse Fournaise, son of the owner,

and his hat was part of the typical sportsman's gear. The *canotier* on the right is the painter Gustave Caillebotte; an avid and accomplished rower, he shows the nonchalance of the passionate amateur, completing his gear with a jaunty boater instead of the regular soft hat.

Renoir's sitters wear a variety of costumes, reflecting the diverse interests and activities of his friends. Four of the women — including Alphonsine Fournaise, the restaurateur's daughter, who leans on the railing, and Renoir's future wife, the seamstress Aline Charigot, who flirts with a little dog — wear blue, white and red boating garb. Journalist Antonio Maggiolo, chatting with Caillebotte and the actress Angèle, wears a pinstriped sack jacket. There is even elegant urban attire: the top hat sported by critic and art historian Charles Ephrussi and the perfectly matched brown ensemble of actress Jeanne Samary remind the viewer that the city is just a brief train journey away.

Auguste Renoir
(1841–1919)

Two Sisters (On the Terrace)

The deep-blue flannel jacket worn by the young woman depicted in Auguste Renoir's *Two Sisters* identifies her as a boating enthusiast. Although rowers' clubs were exclusively male, women came out to support their favourites, and some women took up the sport outside of organized competition. Unlike the simple male costume of singlet or short-sleeved jersey with comfortable trousers, which granted physical freedom, women's boating wear followed the current stylish silhouette; here the woman's snug jacket is cut so close to the body that it fits like a glove. To complete the ensemble, women wore slim skirts that matched the jacket, lightweight white blouses of cotton lawn or muslin, and red accessories. Fashion dictated that greater consideration was given to style lines and the eye-catching colour combination than to practical comfort.

The little girl is also wearing boating colours: a gauzy white pinafore over a vivid blue dress with a broad white collar. Even the profusion of flowers on her hat conforms to the blue, white and red palette. The one unorthodox choice is the young woman's red hat, which has been embellished with roses; boating costume typically featured a natural straw hat with red trim. But Renoir's interest was in brilliant colour rather than documentary detail, and although he set *Two Sisters* on a small terrace of La Maison Fournaise, his favourite riverside restaurant, in Chatou, the work is an arranged composition with professional models.[10] And it is unlikely that the models were related; art dealer Paul Durand-Ruel purchased the work and gave it its title for exhibition in the Seventh Impressionist Exhibition (1882).[11]

1881
Oil on canvas
100.5 × 81 cm
(39⅝ × 37⅞ in.)
The Art Institute of Chicago

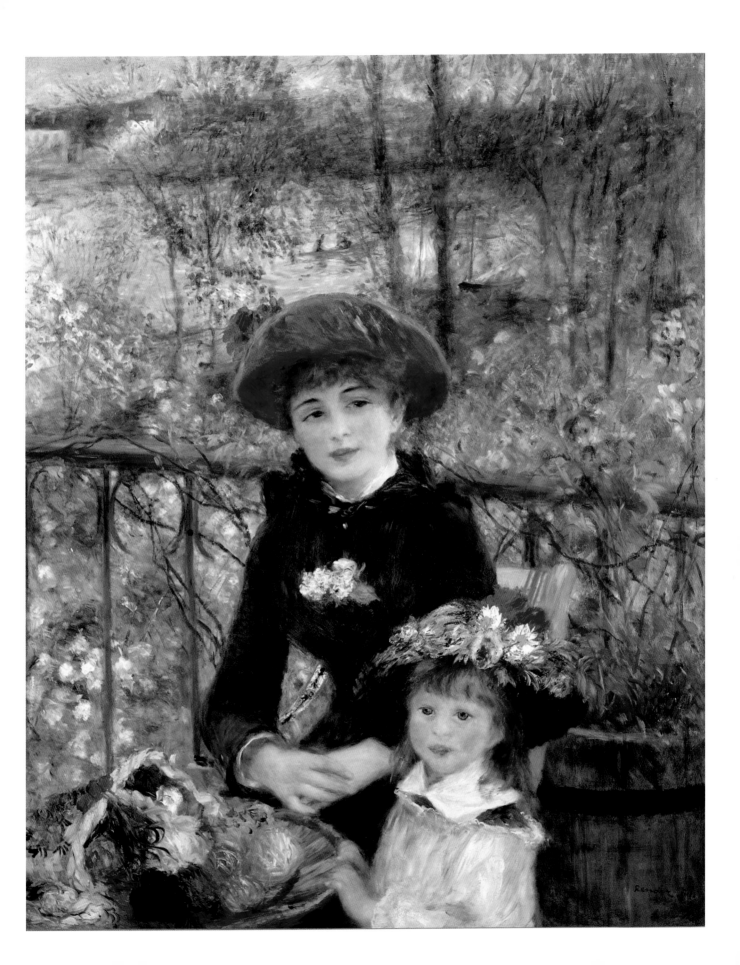

INTERLUDE
Corsets and Crinolines

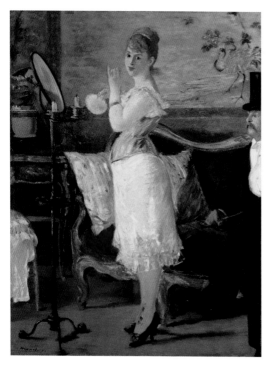

Édouard Manet (1832–1883)
Nana, 1877
Oil on canvas
154 × 115 cm (60⅝ × 45¼ in.)
Hamburger Kunsthalle, Hamburg

Whether wasp-waists, bell skirts or bustles, the extraordinary silhouettes of women's garments owed their contours to well-structured support. The corset shaped the upper body, giving a woman a straighter posture as well as narrowing her waist. Women – and men – had worn corsets for centuries, and the basic design of a reinforced band, tightened with laces and stiffened with stays, had not changed, but new technology brought such improvements as steel grommets for holding the laces and steel stays to replace less resilient baleen (whalebone).

Although ready-to-wear corsets were available, if a woman could afford it she had her corset custom-made. Various styles required different structures: for example, for an hourglass figure, a short corset cupped the breasts above and rounded the hips below; for the long-limbed line, an elongated corset smoothed out natural curves from the bust line to the hipbones. A woman always wore a chemise under her corset, but the corset itself was regarded as the most intimate item of her apparel. Only a woman of suspect reputation would allow a man to see her in her corset; Édouard Manet depicts such a woman, Émile Zola's fictional courtesan Nana (*L'Assommoir*, 1877; *Nana*,

1880) entertaining a man in her dressing room (left).

Prior to 1856, when several patents were filed for the cage crinoline, women supported their voluminous skirts with layers of petticoats. The same effect with none of the weight was achieved by the cage, created from a series of hoops made of cane, baleen or steel, increasing in circumference from waist to hem and held together by tapes (opposite, top). A woman needed to wear only a single petticoat over it and pantaloons below. The outer skirt

Honoré Daumier (1808–1879)
Actualités: 'Manière d'utiliser les jupons nouvellement mis a la mode', from *Le Charivari*, 1856, lithograph
Musée des Beaux-Arts, Palais Longchamp, Marseille

Crinoline Factory, 1865, engraving, France

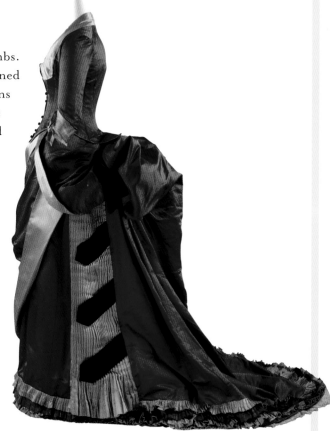

Evening dress, 1884–86
Silk
The Metropolitan Museum of Art,
New York

floated over the hooped structure, creating an unprecedented spherical volume, much to the delight of cartoonists (opposite, right). By 1858 skirts had reached their largest dimensions, and within a few years the rounded silhouette gave way to a slimmer line that was achieved with short, flattened hoops at the front of the cage and elliptical hoops sweeping the skirt's volume to the back. Tie-backs, tapes and bows emphasized the new contour, and by the end of the 1860s a hidden bustle added support.

The *tournure* (a rounded, high-placed bustle) disappeared when columnar lines came into fashion in about 1876. The slim line was not for every woman; it required a long, restricting corset and a petticoat that encased the limbs. By 1883 the bustle had returned in unprecedented proportions as the *strapontin* (right); while the sides of the skirt retained the slim line, the great extension of the back was paired with more fabric in the front, giving a woman more freedom to move. To support the *strapontin*, women wore *crinolettes* hidden between the bustle fabric and the skirt, allowing them to sweep the whole upper contraption to one side for sitting; some supports were even hinged, in order to collapse when a woman sat and spring back when she stood.

Notes

THE STYLE OF MODERNITY

1 Charles Baudelaire, 'The Painter of Modern Life' (1863), in Charles Baudelaire, *The Painter of Modern Life and Other Essays*, tr. Jonathan Mayne, London (Phaidon) 2010, pp. 12–13.

2 Baudelaire concluded his 'Salon of 1845' with a call to acknowledge the 'heroism of *modern life*', an idea he pursued in detail in his 'Salon of 1846'. See Charles Baudelaire, *Art in Paris 1845–1862: Salons and Other Exhibitions*, tr. Jonathan Mayne, Ithaca, NY (Cornell University Press) 1981, pp. 32, 116–20.

3 Work slowed and then stopped during the tumultuous months of the Franco-Prussian War (July 1870–May 1871). Napoleon III was deposed after his defeat at the Battle of Sedan (2 September 1870). The Third Republic was established within days to replace his regime. The Prussian siege of Paris (January 1871) and the civil turmoil during the insurgency that led to the brief rule of the Paris Commune (18 March to 28 May 1871) caused extensive damage to the newly built structures, but aspects of the Haussmann plan, as well as repair, were taken up in June 1871, shortly after the Third Republic regained power.

4 Émile Zola, *The Kill* (*La Curée*; 1872), tr. Brian Nelson, Oxford (Oxford University Press) 2004, p. 68.

5 Émile Zola, 'Les Actualistes', *L'Évènement*, 24 May 1868, quoted in Charles F. Stuckey, ed., *Monet: A Retrospective*, New York (Park Lane) 1986, p. 38.

6 The eight Impressionist exhibitions were held in the years 1874, 1876, 1877, 1879, 1880, 1881, 1882 and 1886. The venues and the participants varied over the years. Manet, by choice, never exhibited his works at any of these exhibitions. For a complete history of the group and their exhibitions, see *The New Painting: Impressionism 1874–1886*, exhib. cat., ed. Charles S. Moffett, Washington, D.C., National Gallery of Art, January–April 1986; San Francisco, Fine Arts Museum of San Francisco, April–July 1986.

7 Ernest Chesneau, *Paris-Journal*, 7 May 1874, quoted in *ibid.*, p. 130.

8 Baudelaire (1863), p. 9.

9 Caillebotte painted views of passers-by on the Pont de l'Europe from several perspectives. See also pp. 48–49 of this book.

10 Baudelaire (1863), p. 12.

11 For accounts of the extravagance of the Empress's wardrobe, see Ross King, *The Judgment of Paris: The Revolutionary Decade that Gave the World Impressionism*, New York (Walker and Company) 2006, p. 122; and Diana De Marly, *Worth: Father of Haute Couture*, London (Elm Tree) 1980, pp. 44–45.

12 Zola (1872), p. 99.

CUTTING A FIGURE

1 Guy de Maupassant, *Bel-Ami* (1885), tr. Douglas Parmée, London (Penguin) 1975, p. 35.

2 *Ibid.*, p. 44.

3 Octave Uzanne, *La Femme à Paris* (1894), quoted in Marie Simon, *Fashion in Art: The Second Empire and Impressionism*, London (Zwemmer) 1995, p. 129.

4 Émile Zola, 'The Realists at the Salon', *L'Évènement*, 11 May 1866, quoted in Elizabeth Gilmore Holt, ed., *From the Classicists to the Impressionists*, New Haven, Conn., and London (Yale University Press) 1986, p. 386.

5 *L'Artiste*, 15 June 1866, quoted in Ross King, *The Judgment of Paris: The Revolutionary Decade that Gave the World Impressionism*, New York (Walker and Company) 2006, p. 183.

6 The cut of Doncieux's skirt is in contrast to the bell-shaped, supported silhouette of previous seasons. Whether Doncieux is even wearing a crinoline beneath her skirt has been a subject of debate.

7 'The laughing blond Manet,/ Emanating grace, Gay subtle and charming,/ With the beard of an Apollo,/ Had from head to toe/ The appearance of a gentleman.' Quoted in Françoise Cachin, *Manet*, tr. Emily Read, New York (Henry Holt) 1991. De Banville was a friend of the painter.

8 Gloria Lynn Groom and Douglas W. Druick, *The Age of French Impressionism: Masterpieces from the Art Institute of Chicago*, Chicago (The Art Institute of Chicago) 2010, p. 36. The critic is not identified. It may have been the conservative critic Albert Wolff, who in a review in *Le Figaro* in 1873 assured his readers that Manet was a 'man of the world, with a refined and ironic smile', despite the rough appearance of so many of his subjects. Quoted in King (2006), p. 328.

9 No specific inventor can be credited with the development of the cage crinoline, but in 1856 patents were filed in France by M. Tavernier, in England by C. Amet, and in the United States by W.S. Thomson.

10 I am grateful to Kristan M. Hanson for sharing her ideas on this topic and allowing me to read her unpublished essay '"Living Style": Painting and Performing the French Fashion for Dress *à l'espagnole*'.

11 Other trends included the zouave, a loosely cut jacket inspired by the uniform worn by French North African troops, and the red, braid-trimmed Garibaldi shirt (named after Guiseppe Garibaldi, leader of the Italian unification movement; his followers were called 'Red shirts'). The tightly fitted Garibaldi shirt was worn as a bodice, often under a zouave jacket.

12 Renoir's couple have long been identified as the painter Alfred Sisley (1839–1899) and his wife, Marie Lescouezec. But scholars at the Wallraf-Richartz-Museum in Cologne, noting that the woman did not resemble Lescouezec, have called this into question and suggest that the generic reference 'The Couple' is a more apt title. See www.wallraf.museum/index.php?id=227&L=1 (accessed 6 February 2012).

13 Although Carolus-Duran debuted the portrait at the Salon of 1869, James saw the work exhibited in the newly renovated Odéon Theatre in 1875. Henry James, 'Paris as It Is', 6 December 1875, in Henry James, *Parisian Sketches: Letters to the 'New York Tribune' 1875–1876*, ed. Leon Edel and Ilse Dusoir Lind, New York (New York University Press) 1957, p. 21. Carolus-Duran's wife, Pauline Croisette (1839–1912), was also a painter, specializing in pastels and miniatures.

14 This includes eleven oils, three etchings and two watercolours. See *Manet: The Man Who Invented Modernity*, exhib. cat. by Stéphane Guégan, Paris, Musée d'Orsay, April–July 2011, p. 185.

15 Most scholars believe that the work was painted in a studio rather than a parlour, but they are divided as to whether the studio belonged to Morisot or Manet.

16 Quoted in *Manet* (2011), p. 185.

17 The fact that Tissot remained in siege-bound Paris during the Franco-Prussian War and through the turbulent months of the Commune has led to speculation that his abrupt departure in June 1871 was owing to radical affiliations. See *James Tissot: Victorian Life/Modern Love*, exhib. cat. by Nancy Rose Marshall, New Haven, Conn., Quebec and Buffalo, 1999–2000, p. 11. He returned to Paris in 1882.

18 From an advertisement promoting French designs, quoted in C. Willett Cunnington, *English Women's Clothing in the Nineteenth Century*, New York (Dover Publications) 1990, p. 270. The text attributes this move towards ostentation to the French desire 'to make as much money as they can' and then show it off.

ON THE STREET

1 Théophile Gautier, preface to Édouard Fournier, *Paris démoli* (1855), quoted in Robert L. Herbert, *Impressionism: Art, Leisure and Parisian Society*, New Haven, Conn., and London (Yale University Press) 1988, p. 4.

2 Elie Frébault, *Vie de Paris* (1878), quoted in Ruth E. Iskin, *Modern Women and Parisian Consumer Culture in Impressionist Painting*, Cambridge (Cambridge University Press) 2007, p. 143.

3 Traditionally, the word 'fascinator' referred to a lace or crocheted shawl, secured to the crown of the head or to a hat, and draped down over the back of the head to as far as the shoulders. The term has been revived in recent years to describe the whimsical cocktail hats by such designers as Stephen Jones and Philip Treacy.

4 During the winter months of 1876 and 1877, Monet painted at least twelve canvases on site at the Gare Saint-Lazare; he exhibited six as a group at the Third Impressionist Exhibition in 1877. See Daniel Wildenstein, *Monet: Catalogue Raisonné*, 4 vols., Cologne (Taschen) 1996, vol. 2, pp. 177–82. Caillebotte debuted *The Pont de l'Europe* (1876; p. 12 of this book) in the same exhibition.

5 Philipe Burty, 'Les Ateliers' (1872), quoted in *Manet, 1832–1883*, exhib. cat. by Françoise Cachin and Charles S. Moffett, Paris, Galeries Nationales du Grand Palais, April–August 1983; New York, The Metropolitan Museum of Art, September–November 1983, p. 340. There is much debate as to whether Manet painted the work on site, in a friend's garden or in the studio, although it was undertaken during Manet's deepest engagement with *plein-air* painting, suggesting that the work was painted, in great part, outdoors.

6 See George Heard Hamilton, *Manet and His Critics*, New York (W.W. Norton) 1969, pp. 178–79.

7 The model for the painting was actress Henriette Henriot, but she is posing in character rather than for a portrait.

8 The origins of the term are difficult to trace. It had been used since the late eighteenth century, but as a reference to this specific type of urban woman whose garments declare a self-fashioned image of position and desire it came into use in the mid-nineteenth century. For a discussion

of the term, see Tamar Garb, 'Painting the "Parisienne": James Tissot and the Making of the Modern Woman', in Kathleen Lochnan, ed., *Seductive Surfaces: The Art of Tissot*, New Haven, Conn., and London (Yale University Press) 1999, p. 98; and Marie Simon, *Fashion in Art: The Second Empire and Impressionism*, London (Zwemmer) 1995, pp. 188–89.

9 Émile Zola, *Pot Luck* (*Pot-Bouille*; 1883), tr. Brian Nelson, Oxford (Oxford University Press) 2009, p. 230.

10 Charles Baudelaire, 'The Painter of Modern Life' (1863), in Charles Baudelaire, *The Painter of Modern Life and Other Essays*, tr. Jonathan Mayne, London (Phaidon) 2010, p. 9.

11 Émile Zola, *La Bête Humaine* (1890), tr. Roger Pearson, Oxford (Oxford University Press) 1996, p. 3.

12 Caillebotte painted views of passers-by on the Pont de l'Europe from several perspectives. See also p. 12 of this book.

13 Henry Tuckerman, *Papers About Paris*, New York (Putnam) 1867, pp. 67, 17. Tuckerman had visited Paris twenty years earlier, so he was able to compare the current state of the city with that prior to the renovations.

14 For a selection of sketches, see *Gustave Caillebotte: Urban Impressionist*, exhib. cat. by Anne Distel *et al.*, Paris, Chicago and Los Angeles, 1994–95, pp. 122–39.

15 There has been some debate as to where Manet painted this work. He borrowed Otto Rosen's studio from July 1878 through to March 1879, so it is speculated that he started it there. See *Manet, 1832–1883*, pp. 423–24. Manet often re-created the settings of familiar locations in the studio, and at this late time in his career that seems the more likely circumstance.

16 During the 1840s and 1850s several patents were filed in England for steel-framed manufactured designs, including those of Henry Holland of Birmingham (1840) and Samuel Fox of London (1852).

17 Émile Zola, *The Ladies' Delight* (*Au Bonheur des Dames*; 1883), tr. Robin Buss, London (Penguin) 2001, pp. 184–85.

AT HOME

1 For further speculation about the setting and detailed discussion of the Charpentiers' collection of Japanese art, see *Renoir's Portraits: Impressions of an Age*, exhib. cat. by Colin B. Bailey, Ottawa, Chicago and Fort Worth, Tex., 1997–98.

2 The portrait was part of a commission from Madame Gaudibert's in-laws to paint individual portraits of the younger couple. The elder Gaudiberts were dissatisfied with Monet's first version of their son (*M. Gaudibert in Casual Clothes*) and requested that Monet paint a second version. Both have been lost. See Daniel Wildenstein, *Monet: Catalogue Raisonné*, 4 vols., Cologne (Taschen) 1996, vol. 2, pp. 58–60.

3 The parlour in fact belonged to her father. Monet painted her at the Château des Ardennes-Saint-Louis near Étretat, in Normandy.

4 Monique Lévi-Strauss suggests that the square shawl, with fringe on all four edges, was made of small pieces sewn together. See *The Cashmere Shawl*, tr. Sara Harris Place, New York (Abrams) 1988, p. 49.

5 Émile Zola, in *Revue du XIXe siècle*, 1 January 1867, quoted in *Manet, 1832–1883*, exhib. cat. by Françoise Cachin and Charles S. Moffett, Paris, Galeries Nationales du Grand Palais, April–August 1983; New York, The Metropolitan Museum of Art, September–November 1983, p. 254. The article was an expanded version of one that Zola had written the previous year and published in *L'Évènement* on 7 May 1866.

6 The meaning of the parrot has generated much speculation, from its being a proxy for an intimate companion who sees the woman undressed, to a reference to the well-known courtesan Marie Duplessis, who owned a parrot. See *Manet, 1832–1883*, p. 258; and Ross King, *The Judgment of Paris: The Revolutionary Decade that Gave the World Impressionism*, New York (Walker and Company) 2006, p. 222. Over the centuries, the parrot has been assigned many meanings, from an emblem of wisdom to the sign of mindless chatter. During the sixteenth century, several Northern Renaissance artists included a parrot in depictions of Adam and Eve; see Debra N. Mancoff and Lindsay J. Bosch, *Icons of Beauty: Art, Culture, and the Image of Women*, 2 vols., Santa Barbara, Calif. (Greenwood Press) 2010, vol. 1, p. 259. The explanation for its presence in Manet's painting is likely more literal: after seeing Gustave Courbet's *Woman with a Parrot* in the Salon of 1866, Manet bought an African grey parrot. He kept it in his studio, and may have included it in this work as a tribute to his fellow realist painter.

7 Several scholars have suggested that the painting is an allegory of the senses. The violets could represent scent; the monocle, sight; the silk, touch; the peeled orange, taste; and the parrot, hearing. See *Manet, 1832–1883*, p. 258.

8 *Ibid.*, p. 254.

9 The son of a wealthy lawyer, Maître held minor posts in the city government that allowed him plenty of time to pursue his interest in avant-garde art. His mistress, Camille, was known as Rapha, and although she referred to herself as Madame Edmond

Maître on occasion, they never married. Her birth and death dates remain unknown, but she lived with Maître until his death. See *Renoir's Portraits*, p. 114.

10 Quoted in Alden O'Brien, 'Maternity Dress', in Valerie Steele, ed., *The Berg Companion to Fashion*, Oxford (Berg) 2010, p. 502.

11 Edmond de Goncourt, 9 May 1879, quoted in Diana De Marly, *Worth: Father of Haute Couture*, London (Elm Tree) 1980, p. 140.

12 Quoted in Marc Elder, *A Giverny, Chez Claude Monet*, Paris (Bernheim-Jeune) 1924, p. 70. Author's translation from French.

13 See, for example, Monet's *The Luncheon* (1873), Musée d'Orsay, Paris.

14 Despite Françoise Cachin and Charles S. Moffett's claim that the hat belonged to Manet's wife, Suzanne, the hat is clearly represented in the 1873 painting by Monet mentioned in the previous note. Also, the hat worn by Suzanne Manet in works that they cite, such as *On the Beach* (1873; Musée d'Orsay, Paris), has the style lines of a bonnet rather than the forward tilt of the rakish hat. See *Manet, 1832–1883*, p. 363.

15 Auguste Renoir, *Madame Monet and Her Son in Their Garden at Argenteuil* (1874; National Gallery of Art, Washington, D.C.). Monet, in turn, painted the image of Manet painting (Claude Monet, *Manet Painting in Monet's Garden*, location unknown), suggesting that he stopped tending his plants to pick up his palette or that, unlike Renoir, he did not work simultaneously with Manet.

16 Charpentier's authors included Émile Zola, Gustave Flaubert and Edmond de Goncourt. In April 1879 he founded the illustrated journal *La Vie Moderne* to promote modern-life subjects in art and literature, and he held occasional art exhibitions in his publishing house.

17 In an interview given in 1904, Renoir stated that Madame Charpentier 'had wanted the work to be hung well and knew members of the jury on which she could prevail'. Quoted in *Renoir's Portraits*, p. 164.

18 Anonymous journalist, quoted in Frederick Sweet, *Miss Mary Cassatt: Impressionist from Pennsylvania*, Norman, Okla. (University of Oklahoma Press) 1966, p. 130.

19 Guy de Maupassant, *Bel-Ami* (1885), tr. Douglas Parmée, London (Penguin) 1975, p. 356. The conservatory belonged to the protagonist's employer, a self-made newspaper magnate.

20 We know Madame Guillemet's origins, but her first name does not seem to have been recorded. Also, it is not known whether Manet painted the scene in an actual conservatory or staged it in his studio.

21 See *John Singer Sargent*, exhib. cat., ed. Elaine Kilmurray and Richard Ormond, London, Washington, D.C., and Boston, 1998–99, p. 96.

22 In a further act of provocation, Pozzi is said to have displayed the portrait, under a cloth drape, in the drawing room of his Paris apartment.

IN THE PARK

1 Émile Zola, *The Kill* (*La Curée*; 1872), tr. Brian Nelson, Oxford (Oxford University Press) 2004, p. 8.

2 Edmond Texier, in *Tableau de Paris* (1852), noted that 3 p.m. was the promenade hour in the Bois de Boulogne, and it was 'where everything happens and everything changes, where people greet, hate, envy, and admire each other.' Quoted in Philippe Perrot, *Fashioning the Bourgeoisie: A History of Clothing in the Nineteenth Century*, tr. Richard Bienvenu, Princeton, NJ (Princeton University Press) 1994, p. 173.

3 Robert L. Herbert quotes the increase from 47 acres to 4500 acres between 1848 and 1870. See Robert L. Herbert, *Impressionism: Art, Leisure and Parisian Society*, New Haven, Conn., and London (Yale University Press) 1988, pp. 141–42.

4 Émile Zola, 'The Actualistes', *L'Évènement*, 24 May 1868, quoted in Charles F. Stuckey, ed., *Monet: A Retrospective*, New York (Park Lane) 1985, p. 38.

5 *Ibid.*

6 The distinctive 'señorita' is curved open above the waist in the front and has shaped basques in the back. This was one of many fashionable jackets worn with both day and evening dresses in 1865. See C. Willett Cunnington, *English Women's Clothing in the Nineteenth Century*, New York (Dover) 1990, p. 222. Soutache trim is a narrow, flat braid twisted into curvilinear or geometric patterns. It became very popular in the mid-1860s as the increased use of sewing machines made it easy to apply.

7 The 1863 design was clearly an experiment, worn only by Marie Worth, the couturier's wife. Worth chose the name 'princess' in part to attract the patronage of the tall, slender Princess of Wales, who had shown a preference for other couturiers. See Diana De Marly, *Worth: Father of Haute Couture*, London (Elm Tree) 1980, pp. 85, 143–44.

8 Charles Baudelaire, 'The Painter of Modern Life' (1863), in Charles Baudelaire, *The Painter of Modern Life and Other Essays*, tr. Jonathan Mayne, London (Phaidon) 2010, p. 13.

9 The Morisot-Manet family bought the property in 1881. The construction of the house took two years. By 1883 they were settled in their new home.

10 Paule Gobillard, unpublished memoir, quoted in Anne Higonnet, *Berthe Morisot's Images of Women*, Cambridge, Mass. (Harvard University Press) 1992, p. 65.

11 Lydia was ill with Bright's disease and would die two years later of kidney failure. But this work should not be seen as a portrait of a woman with ill health. Lydia lived with her sister and frequently modelled for works that emphasized observation and sensations rather than likeness and biography.

12 Émile Zola, *Pot Luck* (*Pot-Bouille*; 1883), tr. Brian Nelson, Oxford (Oxford University Press) 2009, p. 141.

13 For a full account of this process, see Frank Zuccari and Allison Langely, 'Seurat's Working Process: The Compositional Evolution of *La Grande Jatte*', in *Seurat and the Making of 'La Grande Jatte'*, exhib. cat. by Robert L. Herbert, Chicago, The Art Institute of Chicago, June–September 2004, pp. 178–95.

14 These changes, as well as others to the couple's silhouette, were discovered through infrared reflectography and X-radiographic analyses. See *ibid.*, p. 184.

MAKING THE SCENE

1 Henry Tuckerman, *Papers About Paris*, New York (Putnam) 1867, p. 25.

2 Antonin Proust, 'Édouard Manet: Souvenirs', *La Revue blanche*, February–May 1897, pp. 170–71.

3 Others include Manet's brother Eugène, in the centre of the painting, in light buff trousers and a top hat; the composer Jacques Offenbach, seated behind the woman in the striped dress; and Henri Fantin-Latour, Théophile Gautier, sculptor and writer Zacharie Astruc and Charles Baudelaire. The women in the blue bonnets are identified as Madame Lejosne (on the left) and Madame Loubens or Madame Offenbach on the right. See *Manet, 1832–1883*, exhib. cat. by Françoise Cachin and Charles S. Moffett, Paris, Galeries Nationales du Grand Palais, April–August 1983; New York, The Metropolitan Museum of Art, September–November 1983, pp. 122–23.

4 Charles Baudelaire, 'The Painter of Modern Life' (1863), in Charles Baudelaire, *The Painter of Modern Life and Other Essays*, tr. Jonathan Mayne, London (Phaidon), 2010, p. 12. It is worth noting that this landmark essay was published the year after Manet completed the painting. Both men were seeking a way to express modernity in painting, and, as friends, no doubt they exchanged ideas.

5 Various sources provide differing dates and histories of the site. The older of the two mills was built between 1611 and 1622, and was originally called Blute-Fin; that is the one now called Moulin de la Galette. The other is called Radet. The mills were owned by the Debray family, and it is uncertain exactly when they ceased to function as active mills. According to Robert L. Herbert, the Moulin de la Galette occasionally ground iris root for a local perfumer, even after the function of the site turned to entertainment. See Robert L. Herbert, *Impressionism: Art, Leisure and Parisian Society*, New Haven, Conn., and London (Yale University Press) 1988, p. 136.

6 The women have been identified as Estelle (the sister of one of Renoir's regular models) in the striped dress and Margot (Marguerite Legrand) dancing in the white dress with the blue underskirt. Her partner is said to be a Cuban painter named Solares. The three men in the right-hand foreground are painters Pierre-Franc Lamy (1855–1919) and Norbert Goeneutte (1854–1894) and critic Georges Rivière. Among the male dancers are painter Henri Gervex (1852–1929) and writer Paul Lhote. Herbert (*ibid.*) notes that all the men were at least a decade younger than Renoir, stressing that the Moulin de la Galette attracted a youthful clientele.

7 Georges Rivière, in a review of the Third Impressionist Exhibition (April 1877), quoted in *ibid.*, p. 139.

8 *Degas at the Races*, exhib. cat. by Jean Sutherland Boggs, National Gallery of Art, Washington, D.C., April–July 1998, p. 38.

9 Henry James, 'Summer in France', 22 July 1876, in Henry James, *Parisian Sketches: Letters to the 'New York Tribune' 1875–1876*, ed. Leon Edel and Ilse Dusoir Lind, New York (New York University Press) 1957, p. 190.

10 Georges Rivière, *L'Impressioniste: Journal d'art* (1877), quoted in Hollis Clayson, 'The Sexual Politics of Impressionist Illegibility', in Richard Kendall and Griselda Pollock, eds, *Dealing with Degas: Representations of Women and the Politics of Vision*, New York (Universe) 1992, p. 68. Rivière saw the work at the Third Impressionist Exhibition (1877).

11 Edward King, *My Paris: French Character Sketches*, Boston (Loring) 1868, p. 113. King visited Paris in 1867.

12 Jules Michelet, *La Femme* (1860), quoted in Pamela Todd, *The Impressionists at Leisure*, London (Thames & Hudson) 2007, p. 20.

13 Émile Zola, *The Ladies' Delight* (*Au Bonheur des Dames*; 1883), tr. Robin Buss, London (Penguin) 2001, p. 152.

14 Ellen Andrée also posed for Renoir. She can be seen in *Luncheon of the*

Boating Party (pp. 136–37 of this book) as the woman in the centre of the composition holding a glass.

15 This story is attributed to Louis Gauthier-Lathuille. See John Richardson with Kathleen Adler, *Manet*, London (Phaidon) 1993, p. 110.

16 Balls often followed opera performances. Women generally covered their bare shoulders or revealing décolletage with a wrap. As seen here, fans and large bouquets were also used to add an element of modesty. Some art historians identify the setting of this painting as a theatre, but the women's dresses indicate that it is the opera house.

17 Guy de Maupassant, *Bel-Ami* (1885), tr. Douglas Parmée, London (Penguin) 1975, p. 39.

18 Paul Alexis, quoted in T.J. Clark, *The Painting of Modern Life: Paris in the Art of Manet and His Followers*, New York (Alfred A. Knopf) 1985, p. 239.

ON HOLIDAY

1 Henry James, 'Summer in France', 22 July 1876, in Henry James, *Parisian Sketches: Letters to the 'New York Tribune' 1875–1876*, ed. Leon Edel and Ilse Dusoir Lind, New York (New York University Press) 1957, p. 188. James followed his own advice: he was writing from Le Havre, on the coast of Normandy.

2 Émile Zola, *The Ladies' Delight* (*Au Bonheur des Dames*; 1883), tr. Robin Buss, London (Penguin) 2001, p. 137.

3 See *Renoir's Portraits: Impressions of an Age*, exhib. cat. by Colin B. Bailey, Ottawa, Chicago and Fort Worth, Tex., 1997–98, p. 132.

4 This description is often quoted. See, for example, Diana De Marly, *Worth:*

Father of Haute Couture, London (Elm Tree) 1980, p. 36.

5 As described in the journal *L'Évènement Illustré*; see Pamela Todd, *The Impressionists at Leisure*, London (Thames & Hudson) 2007, p. 85.

6 'Boatmen came from various walks of life, but the women they brought with them all belonged to the class of second-rate ladies of pleasure.' Théodore Duret, *Histoire d'Édouard Manet et de son oeuvre* (1902), quoted in *Manet, 1832–1883*, exhib. cat. by Françoise Cachin and Charles S. Moffett, Paris, Galeries Nationales du Grand Palais, April–August 1983; New York, The Metropolitan Museum of Art, September–November 1983, p. 353. This comment has led many scholars to identify the woman as a prostitute.

7 Despite the air of authenticity and spontaneity, the work was composed. Manet's brother-in-law Rodolph sat for the image of the boatman; the woman is unidentified and was likely a professional model. See *Manet, 1832–1883*, p. 353.

8 It is not known when Caillebotte first took up rowing, but he began to sail in 1876 and he bought his first sailing boat two years later; sailing became an enduring passion. Caillebotte won his first race in 1880, and in 1881 he took up boat design. He eventually built his own boatyard near the house he bought with his brother in 1881 on the River Seine at Petit-Gennevilliers. He was also an active advocate of boating: he held offices in France's premier yachting society, Le Cercle de la Voile; invested in *Le Yacht*, a weekly journal; and published articles on technique and boat design. See *Gustave Caillebotte*, exhib. cat. by Anne Birgitte Fonsmark, Dorothee Hansen and Gry Hedin, Bremen, Copenhagen and Madrid, 2008–2009, pp. 109–19.

9 Draner (Jules Renard) called his spoof *(Steam)boating Party*, a play on the painting's original title, *Partie de bateau*, published in the catalogue for the Fourth Exhibition (1879). See *Gustave Caillebotte: Urban Impressionist*, exhib. cat. by Anne Distel *et al.*, Paris, Chicago and Los Angeles, 1994–95, p. 74.

10 The young woman has been identified as Jeanne Darlaud. She was roughly eighteen years old at the time of the painting; within a few years, she would become known as a light comic actress at the Théâtre Gymnase and the Comédie-Française. The little girl has not been identified. See *Renoir's Portraits*, p. 188.

11 Paul Durand-Ruel purchased the work shortly after it was finished in July 1881. Renoir was no longer interested in active participation in the Impressionist Exhibitions, so for the Seventh Exhibition Durand-Ruel selected twenty-five works from those that he owned. Originally named *On the Terrace*, the *Two Sisters* was displayed with its new title alongside some of Renoir's other works set in Chatou, including *Luncheon of the Boating Party* (pp. 136–37 of this book). See Gloria Lynn Groom and Douglas W. Druick, *The Age of French Impressionism: Masterpieces from the Art Institute of Chicago*, Chicago (The Art Institute of Chicago) 2010, p. 81.

Select Bibliography

HISTORY OF IMPRESSIONISM

Americans in Paris, 1860–1900, exhib. cat. by Kathleen Adler, Erica E. Hirshler and H. Barbara Weinberg, London, Boston and New York, 2006–2007

Gustave Caillebotte, exhib. cat. by Anne Birgitte Fonsmark, Dorothee Hansen and Gry Hedin, Bremen, Copenhagen and Madrid, 2008–2009

Gustave Caillebotte: Urban Impressionist, exhib. cat. by Anne Distel *et al.*, Paris, Chicago and Los Angeles, 1994–95

Mary Cassatt: Modern Woman, exhib. cat. by Judith A. Barter and Erica E. Hirshler, Chicago, Boston and Washington, D.C., 1998–99

T.J. Clark, *The Painting of Modern Life: Paris in the Art of Manet and His Followers*, New York (Alfred A. Knopf) 1985

A Day in the Country: Impressionism and the French Landscape, exhib. cat. by Andrea P.A. Belloli, Los Angeles, Chicago and Paris, 1984–85

Degas, Sickert and Toulouse-Lautrec: London and Paris 1870–1910, exhib. cat. by Anna Gruetzner and Richard Thomson, London, Tate Gallery, October 2005 – January 2006

Francis Franscina and Tamar Garb, *Modernity and Modernism: French Painting in the Nineteenth Century*, New Haven, Conn., and London (Yale University Press) 1993

George Heard Hamilton, *Manet and His Critics*, New York (W.W. Norton) 1969

Robert L. Herbert, *Impressionism: Art, Leisure and Parisian Society*, New Haven, Conn., and London (Yale University Press) 1988

Anne Higonnet, *Berthe Morisot's Images of Women*, Cambridge, Mass., (Harvard University Press) 1992

Impression: Painting Quickly in France, 1860–1890, exhib. cat. by Richard R. Brettell, London, Williamstown, Mass., and Amsterdam, 2000–2001

Impressionists by the Sea, exhib. cat. by John House and David M. Hopkin, London, Washington, D.C., and Hartford, Conn., 2007–2008

Richard Kendall and Griselda Pollock, eds, *Dealing with Degas: Representations of Women and the Politics of Vision*, New York (Universe) 1992

Mary Tompkins Lewis, ed., *Critical Readings in Impressionism and Post-Impressionism: An Anthology*, Berkeley, Calif. (University of California Press) 2007

Kathleen Lochnan, ed., *Seductive Surfaces: The Art of Tissot*, New Haven, Conn., and London (Yale University Press) 1999

Edward Lucie-Smith, *Impressionist Women*, New York (Harmony) 1989

Manet, 1832–1883, exhib. cat. by Françoise Cachin and Charles S. Moffett, Paris, Galeries Nationales du Grand Palais, April–August 1983; New York, The Metropolitan Museum of Art, September–November 1983

Manet: The Man Who Invented Modernity, exhib. cat. by Stéphane Guégan, Paris, Musée d'Orsay, April–July 2011

Manet, Monet and the Gare Saint-Lazare, exhib. cat. by Juliet Wilson Bareau, Paris, Musée d'Orsay, February–May 1998; Washington, D.C., National Gallery of Art, June–September 1998

Manet/Velázquez: The French Taste for Spanish Painting, exhib. cat. by Gary Tinterow and Geneviève Lacambre, Paris, Musée d'Orsay, September 2002 – January 2003; New York, The Metropolitan Museum of Art, March–June 2003

The New Painting: Impressionism 1874–1886, exhib. cat., ed. Charles S. Moffett, Washington, D.C., National Gallery of Art, January–April 1986; San Francisco, The Fine Arts Museum of San Francisco, April–July 1986

The Origins of Impressionism, exhib. cat. by Gary Tinterow and Henri Loyrette, Paris, Galeries Nationales du Grand Palais, April–August 1994; New York, The Metropolitan Museum of Art, September 1994 – January 1995

Renoir's Portraits: Impressions of an Age, exhib. cat. by Colin B. Bailey, Ottawa, Chicago and Fort Worth, Tex., 1997–98

John Rewald, *The History of Impressionism*, New York (The Museum of Modern Art) 1946

Jane Mayo Roos, *Early Impressionism and the French State (1866–1874)*, Cambridge and New York (Cambridge University Press) 1996

Meyer Schapiro, *Impressionism: Reflections and Perceptions*, New York (George Braziller) 1997

Seurat and the Making of 'La Grande Jatte', exhib. cat. by Robert L. Herbert, Chicago, The Art Institute of Chicago, June–September 2004

Belinda Thomson, *Impressionism: Origins, Practices, Reception*, London (Thames & Hudson) 2000

James Tissot: Victorian Life/Modern Love, exhib. cat. by Nancy Rose Marshall, New Haven, Conn., Quebec and Buffalo, 1999–2000

Pamela Todd, *The Impressionists at Home*, London (Thames & Hudson) 2005

—, *The Impressionists at Leisure*, London (Thames & Hudson) 2007

Women in Impressionism: From Mythical Feminine to Modern Woman, exhib. cat., ed. Sisdel Maria Søndergaard, Copenhagen, Ny Carlsberg Glyptotek, October 2006 – January 2007

HISTORY OF DRESS

Diana De Marly, *Worth: Father of Haute Couture*, London (Elm Tree) 1980

Fashioning Fashion: European Dress in Detail, 1700-1915, exhib. cat. by Sharon Sadako Takeda and Kaye Durland Spilker, Los Angeles, Los Angeles County Museum of Art, October 2010 – March 2011

The Opulent Era: Fashions of Worth, Doucet and Pingat, exhib. cat. by Elizabeth A. Coleman, New York, Brooklyn Museum, December 1989 – February 1990

Philippe Perrot, *Fashioning the Bourgeoisie: A History of Clothing in the Nineteenth Century*, tr. Richard Bienvenu, Princeton, NJ (Princeton University Press) 1994

Jan Glier Reeder, *High Style: Masterworks from the Brooklyn Museum Costume Collection at the Metropolitan Museum of Art*, New Haven, Conn., and London (Yale University Press) 2010

Marie Simon, *Fashion in Art: The Second Empire and Impressionism*, London (Zwemmer) 1995

Valerie Steele, *The Corset: A Cultural History*, New Haven, Conn., and London (Yale University Press) 2001

—, *Paris Fashion: A Cultural History*, Oxford (Oxford University Press) 1988

—, ed., *The Berg Companion to Fashion*, Oxford (Berg) 2010

PARIS IN THE NINETEENTH CENTURY

Meredith Clausen, 'The Department Store: Development of the Type', *Journal of Architectural Education*, 39:1, Autumn 1985, pp. 20–29

Alain Corbin, *Women for Hire: Prostitution and Sexuality in France after 1850*, tr. Alan Sheridan, Cambridge, Mass. (Harvard University Press) 1990

Geoffrey Crossick and Serge Jaumain, *Cathedrals of Consumption: The European Department Store, 1850–1939*, Aldershot (Ashgate) 1999

Patrice L.R. Higonnet, *Paris: Capital of the World*, tr. Arthur Goldhammer, Cambridge, Mass. (Belknap Press) 2002

Ruth E. Iskin, *Modern Women and Parisian Consumer Culture in Impressionist Painting*, Cambridge (Cambridge University Press) 2007

Ross King, *The Judgment of Paris: The Revolutionary Decade that Gave the World Impressionism*, New York (Walker and Company) 2006

Alison McQueen, *Empress Eugénie and the Arts: Politics and Visual Culture in the Nineteenth Century*, Farnham (Ashgate) 2011

Paris Cafés: Their Role in the Birth of Modern Art, exhib. cat. by Georges Bernier, New York, The Metropolitan Museum of Art, November–December 1985

Virginia Rounding, *Grandes Horizontales: The Lives and Legends of Four Nineteenth-Century Courtesans*, New York and London (Bloomsbury) 2003

Rebecca L. Spang, *The Invention of the Restaurant: Paris and Modern Gastronomic Culture*, Cambridge, Mass. (Harvard University Press) 2000

NINETEENTH-CENTURY ACCOUNTS OF PARIS

Charles Baudelaire, *Art in Paris 1845–1862: Salons and Other Exhibitions*, tr. Jonathan Mayne, Ithaca, NY (Cornell University Press) 1981

—, *The Painter of Modern Life and Other Essays*, tr. Jonathan Mayne, London (Phaidon) 2010

Henry James, *Parisian Sketches: Letters to the 'New York Tribune' 1875–1876*, ed. Leon Edel and Ilse Dusoir Lind, New York (New York University Press) 1957

Edward King, *My Paris: French Character Sketches*, Boston (Loring) 1868

Jules Michelet, *Woman (La Femme)*, tr. John Williamson Palmer, New York (Rudd and Carleton) 1860

Henry Tuckerman, *Papers About Paris*, New York (Putnam) 1867

Octave Uzanne, *Fashion in Paris*, tr. Mary Loyd, London (Heinemann) 1898

NOVELS OF PARIS

Guy de Maupassant, *Bel-Ami* (1885), tr. Douglas Parmée, London (Penguin) 1975

Émile Zola, *The Kill* (*La Curée*; 1872), tr. Brian Nelson, Oxford (Oxford University Press) 2004

—, *The Ladies' Delight* (*Au Bonheur des Dames*; 1883), tr. Robin Buss, London (Penguin) 2001

—, *The Masterpiece* (*L'Oeuvre*; 1886), tr. Thomas Walton, rev. tr. Roger Pearson, Oxford (Oxford University Press) 1999

—, *Pot Luck* (*Pot-Bouille*; 1883), tr. Brian Nelson, Oxford (Oxford University Press) 2009

Picture Credits

Acknowledgements

For my mother, Elinor R. Mancoff, who, in her youth, dreamed of fashion and Paris

I should like to thank to Claire Chandler and Hugh Merrell at Merrell Publishers for the opportunity to write about this delightful topic, and for their encouragement throughout the project. My thanks also go to Merrell staff members Marion Moisy for her thoughtful editing; Nick Wheldon for his unstinting support in assembling the illustrations; and Nicola Bailey, for producing the beautiful design. Thanks, too, to Anna Siebert, picture researcher at AKG-Images, for her advice, and to Merrell freelancers Elizabeth Tatham and Hilary Bird for their work in getting the text ready for production.

I am grateful for the assistance of Holly Stec Dankert, Jennifer A. Smith and the staff of the John Flaxman Library at the School of the Art Institute of Chicago. Also at the School of the Art Institute of Chicago, I should like to acknowledge Lisa Wainwright, Dean of Faculty and Vice-President of Academic Affairs, and David Raskin, Chair of the Department of Art History, Theory, and Criticism, in their support of my research. And I thank my colleagues Michal Raz-Russo, Natalie VanOverbeke, Paul B. Jaskot and Anna di Cesare for sharing their ideas. My deepest appreciation goes to my expert research assistant Kristan M. Hanson, whose insights – as well as hard work – made an invaluable contribution.

Index

First published 2012 by
Merrell Publishers, London and New York

Merrell Publishers Limited
81 Southwark Street
London SE1 0HX

merrellpublishers.com

British Library Cataloguing-in-Publication Data:
Mancoff, Debra N., 1950–
Fashion in Impressionist Paris.
1. Fashion in art. 2. Painting, French–19th
century–Themes, motives. 3. Impressionism
(Art)–France–Paris. 4. Fashion–France–
Paris–History–19th century–Sources.
I. Title II. Musée d'Orsay. III. Metropolitan Museum
of Art (New York, N.Y.) IV. Art Institute of Chicago.
758.9'391'00944361–dc23

ISBN 978-1-8589-4582-8

Produced by Merrell Publishers Limited
Designed by Nicola Bailey
Project-managed by Marion Moisy
Proof-read by Elizabeth Tatham
Indexed by Hilary Bird

Printed and bound in China

Jacket front: Detail of Gustave Caillebotte, *The Pont
de l'Europe*, 1876 (see page 12)

Jacket back, clockwise from top left: Auguste Renoir,
The Swing, 1876 (see page 87); Édouard Manet, *A Bar
at the Folies-Bergère*, 1881–82 (see pages 116–17); Mary
Cassatt, *The Loge*, 1882 (see page 115); Edgar Degas,
Place de la Concorde, 1875 (see pages 46–47)

Pages 2–3: Detail of Mary Cassatt, *The Loge*, 1882
(see page 115)

Page 4: Detail of Georges Seurat, *A Sunday on La
Grande Jatte – 1884*, 1884–86 (see pages 94–95)

Pages 142–43: Detail of Édouard Manet, *In the
Conservatory*, 1879 (see pages 74–75)

Page 160: Detail of Édouard Manet, *A Bar at the
Folies-Bergère*, 1881–82 (see pages 116–17)

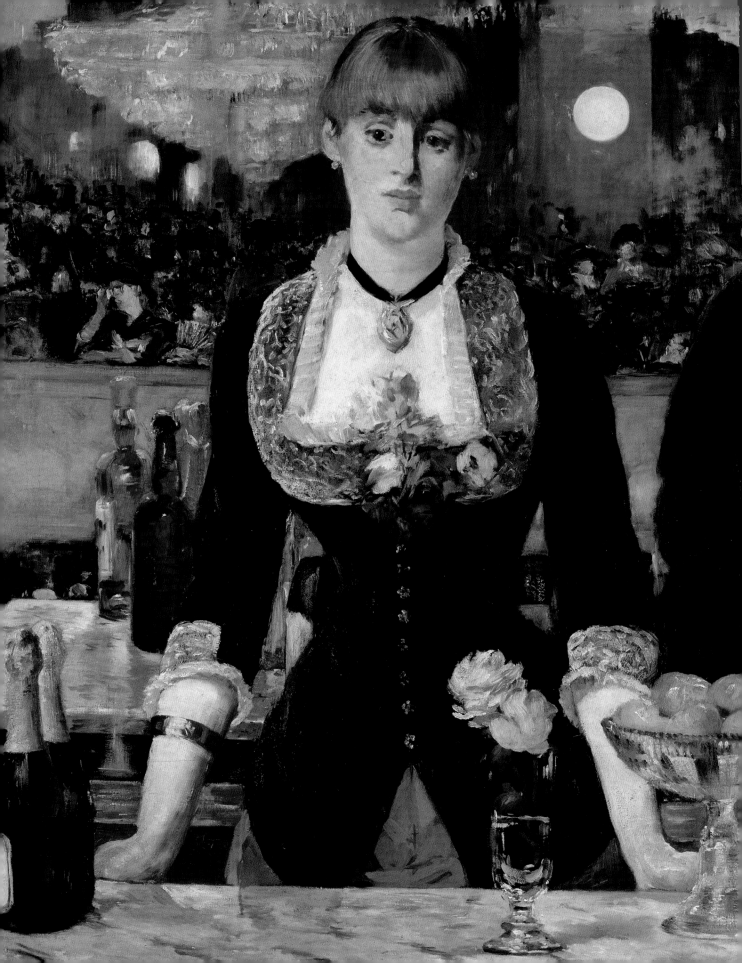